This publication was made possible by the generous support from:

The City of Joliet Mayor Arthur Schultz and Councilmen Joseph Shetina,
Timothy Brophy, Anthony Uremovic, Alex Ledesma, Warren Dorris,
Thomas Giarrante, Robert Hacker, and Michael Turk

Lawrence M. Walsh, Illinois State Senator, 43rd District

John C. McGuire, Illinois State Representative, 86th District

The Illinois Humanities Council, the National Endowment for the Humanities,
and the Illinois General Assembly

The Heritage Corridor Convention and Visitors Bureau

The Illinois State Museum Lockport Gallery

Murals were made possible by the generous support from the City of Joliet,
the Workforce Development Council of Will County, and the
Joliet City Center Partnership of the Joliet/Will County Center for Economic Development Foundation

murals

THE GREAT WALLS OF JOLIET

BY JEFF HUEBNER

Distributed by the
University of Illinois Press
Urbana and Chicago
for the Friends of Community Public Art
Joliet, Illinois

This book is printed on acid-free paper.
Printing/Binding: Verona, Italy

Friends of Community Public Art
1819 N. Center Street
Joliet, IL 60435-2513

Library of Congress Cataloging-in-Publication Data
Huebner, Jeff, 1954-
 Murals: the great walls of Joliet / Jeff Huebner
 p. cm.
 Includes bibliographical references and index.
 ISBN 0-252-06957-9 (acid-free paper)
1. Mural painting and decoration, American—Illinois—Joliet.
2. Mural painting and decoration—20th century—Illinois—Joliet.
3. Public Art—Illinois—Joliet. I. Title
 ND2638.J65H84 2001
 751.7'3'0977325—dc21 00-011909

P 5 4 3 2 1

Publisher: Friends of Community Public Art

Project Director: Kathleen Farrell

Art Editor: Kathleen Scarboro

Copy Editor: Faye Andrashko, Jim Zimmer

Production Manager: Marcia Pauling

Fiscal Manager: Karen Lega

Independent Evaluator: Ronne Hartfield

Photo Editor: Dante DiBartolo

Photographers: Ron Molk, Nicole Brints-Viner

Writer: Jeff Huebner

Designer: Jeanne Nemcek, 4439 Design

Front Cover Art by Jesus Rodriguez, 2000
Back Cover Art by Kathleen Scarboro, 1999

Jeff Huebner is an arts journalist and writer. A regular contributor to the *Chicago Reader*, his articles on public and community art have also appeared in such local and national publications as *ARTnews, Public Art Review, New Art Examiner, High Performance, Sculpture, Ceramics Monthly, Labor's Heritage, Chicago Magazine,* and the *Chicago Tribune* and *Chicago Sun-Times*. He is writer and editor of the *Chicago Public Art Group Newsmagazine*. He is co-author, with Olivia Gude, of *Urban Art Chicago: A Guide to Community Murals, Mosaics, and Sculptures* (Ivan R. Dee, Publisher).

Contents

Acknowledgements

Friends of Community Public Art wishes to acknowledge the generous financial support from the City of Joliet: Mayor Arthur Schultz and Councilmen Joseph Shetina, Timothy Brophy, Anthony Uremovic, Alex Ledesma, Warren Dorris, Thomas Giarrante, Robert Hacker and Michael Turk. FCPA would also like to thank from the City of Joliet: John Mezera, City Manager; Jim Shappard, Deputy City Manager; and Jim Haller, Director of Community and Economic Development.

The Illinois Humanities Council, the National Endowment for the Humanities, and the Illinois General Assembly provided additional financial support for the book.

Jim Zimmer, Director of the Illinois State Museum Lockport Gallery, provided advice and guidance essential to the publication. FCPA would like to thank Ruth Modric for her expertise on purchasing and printing. The Heritage Corridor Convention & Visitors Bureau provided financial support for the photography.

Many individuals and organizations provided historical material to the lead artists, and additional material to the writer of this book. They include professional and lay historians Richard Joyce, Dr. Robert Sterling, Billie Limacher, John Lamb, Lois Lindstrom, Ted and Irma Chuk, Theodore Lega, Dorothy Cromby, Hope Rajala, Rabbi Michal Mendelsohn, Joseph Belman, Navor Rodriguez, and Dennis Maiotti. Lead artists Thomas Manley, Carla Carr, Kathleen Scarboro, Kathleen Farrell, Jesus Rodriguez, and Lucija Dragovan did original research for their murals and provided this research to the author. FCPA lead artists and writer Jeff Huebner were further aided by staff at the Isle a la Cache Museum in Romeoville, Joliet Historical Society and Museum, Will County Historical Society, American Italian Cultural Society, Southeast Side Italian Club, Irish American Society, Slovenian Women's Union, Joliet Public Library, and Joliet Township High School Archives.

The City of Joliet sponsored the murals depicted in this book. Additional financial support for the murals was provided, in part, by grants from the Canal Corridor Association (Illinois & Michigan Canal mural), Billie Limacher Bicentennial Park (I & M Canal mural), and

First Midwest Bank Trust of Joliet (installation of murals). The following organizations provided general financial support: Harrah's Casino; the Center for Economic Development, Will County Chamber of Commerce; WJOL Radio, AT&T Cable; *Herald News*; Governors State University, Illinois; the Cultural Arts Center of the Joliet Area; Chicago Public Art Group; and members of Friends of Community Public Art.

The mural program would not be complete without community outreach through staff development and education, postcards, posters, dedication celebrations, scale model exhibitions, and media coverage. In addition to the City of Joliet, FCPA would like to thank other organizations and individuals that aided in our outreach program. They include Caterpillar, Inc. (education), Heritage Corridor Convention and Visitors Bureau (brochure and reception), Joliet City Center Partnership of the Joliet/Will County Center for Economic Development Foundation (informational plaques), Harrah's Casino (reception), American Italian Cultural Society (postcard, brochure, and celebration), Irish American Society (postcard and celebration), Joliet Township High School District #204 (postcard, posters, and celebration), Joliet Grade School District #86 (celebration), Will-Grundy Counties Building Trades (poster), U.S. Congressman Jerry Weller (exhibition reception), Embossed Graphics (reception invitations), Taylor Wall Covering (postcard), Casa Blanca Grocer (postcard), Marquez Financial Services (postcard), First National Bank (postcard), Provena St. Joseph Medical Center (postcard), Will County Farm Bureau (postcard), American Federation of Teachers local #604 (poster), University of St. Francis (exhibition reception, postcard, and poster), R.R. Donnelly (poster), Mark Rogovin, Joliet Junior College Art Department, and the Spanish Center. Media coverage has been provided by *The Joliet Times Weekly*, *El Conquistador Newspaper*, *Herald News*, AT&T Cable, Illinois State Museum Lockport Gallery's Picture This cable TV program, Diane Stonitsch with Joliet Cable Access Channel 6, and WJOL radio.

The Workforce Development Council of Will County provided additional labor for the mural program. We wish to thank Pasch & Sons, Tom Polyak of Corsetti Steel, and the Homebuilders Association for donating their labor to install murals painted on signboard. Ireland, Ltd., and Joliet Rental provided equipment, and many businesses provided the mural workers access to their facilities during job site mural production.

By Kathleen Farrell

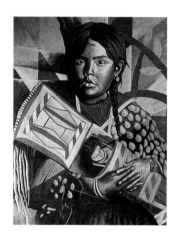

The **Great Walls of Joliet: Taking History and Heritage into the Future** explores the extraordinary contemporary public murals created in Joliet, Illinois, between 1991 and 1999. The book also reveals the unique relationship developed between Friends of Community Public Art (FCPA), its artists and the Joliet community.

Little did I know when I set out to create a community-oriented public art movement in Joliet in 1975 that twenty-five years later Joliet would boast over eighty community-based outdoor murals, mosaics and sculptures. This art movement was able to grow and flower due to the addition of Joliet artist Kathleen Scarboro in 1977. It was the combination of her highly developed painting skills and ability to stay focused on completing each project that allowed me to concentrate on the necessary community work.

A renewed vigor to Joliet's public art movement began in 1991 when Kathleen and I began an in-depth partnership with the City of Joliet. Through the visionary support of the mayor, city council, City Manager John Mezera and Director of Community and Economic Development Jim Haller, we were able to generate the necessary financial support for Joliet's public art program to flourish. John Mezera's and Jim Haller's professional calm were welcome voices of reason to my excitable nature when artistic and political problems needed to be solved.

There has been a coherent and progressive stylistic development of the murals explored in this book. The writer chose to introduce the most recent, most complex, and aesthetically most developed murals first and then allow the reader to follow the path that led to this work. This aesthetic development was created in tandem with the Joliet public as they became comfortable with the mural medium as a vehicle to express its history and vision.

The current murals do not represent absolutely every important topic of history and heritage in Joliet. FCPA will be exploring additional history and heritage topics in the years to come. FCPA, under contract with the City of Joliet, produced fifteen additional murals, mosaics and sculptures in 2000.

A core group of Joliet area artists has been involved in all the community public art explored in this book. This core group also is responsible for the founding of FCPA as a not-for-profit

Taking History into the Future

art organization that serves Joliet and the communities along the Illinois & Michigan Canal Heritage Corridor, which stretches from Lemont, Illinois, in the northeast to LaSalle, Illinois, in the southwest.

Lead artists for FCPA have national and international reputations as professional artists. FCPA requires its artists to have excellent technical drawing and painting skills, to have a deep commitment to creating community-responsive art, and to have an individual point of view and personal style that reflects dedication to skill and community. FCPA reaches out to artists and art students who reflect Joliet's diversity, inviting them to participate in FCPA's rigorous mural certification workshops and on-the-job training programs which mentor assistant artists to become lead artists.

The City of Joliet has worked with the same group of professional, community-oriented artists since 1991. Though a number of these artists were members of the Chicago Public Art Group, the Joliet artists decided they needed a local organization to better serve their needs. In 1997, with the help of the Chicago Public Art Group, FCPA incorporated. The City of Joliet immediately began contracting with FCPA, which, in turn, contracted with member artists for artwork. FCPA gets additional funding from foundations, businesses, labor, and government agencies for education and outreach programs, including apprentice-training classes. These programs further FCPA's goal of representing Joliet's economic, racial, and cultural diversity. FCPA has forty members, eleven lead artists and an active advisory board.

Joliet's diverse citizenry takes an active role in the city's art. Joliet is an old industrial city with a population of 95,000 (based on growth trends since the 1990 census) located thirty-five miles southwest of Chicago. The city's population is fifty-nine percent non-Hispanic white, fifteen percent Hispanic, twenty-five percent African–American, and less than one percent Asian or other. Joliet is predominantly working-class.

It is with great pride that FCPA presents this book in celebration of the glorious art made possible by the combined work of Joliet's talented public artists and the visionary City of Joliet mayor, council members and officials.

FCPA has developed an audience-responsive process for creating community-based history and heritage murals. FCPA works with the City of Joliet using print and electronic media to educate the public about proposed projects. Local professional and lay historians meet each year with lead artists and the director of Community and Economic Development of the City of Joliet to develop a list of possible historical topics that include the often underrepresented minority and working classes. These topics are then submitted to the city manager and city council, who decide which topics are to be developed that year. Once FCPA has contracted with the city to create that year's murals, FCPA distributes the jobs to its lead artists. Although FCPA must compete with bids from commercial mural companies, FCPA still strives to pay living wages to its artists and assistants.

The artists research their topics, gather books and photos, and meet with community members and historians. Often at this stage, FCPA holds group design workshops. Artist members participate in design workshops to brainstorm on design, content and community outreach plans for each project. After this meet-ing, the lead artists solidify their plans for the project, gathering historic photographs and taking new photos of historic sites. In some cases, the artists must recreate scenes they wish to depict by posing local citizens in period costumes.

The lead artist again meets with interested community members and government officials before creating a full color painting of the mural on canvas. In general, the paintings are at a scale of one inch on the canvas equals one foot on the wall. This scale model painting is presented to the city manager, then the council, for approval.

Equipped with a gridded color photocopy of the scale model, the artists and their assistants (using high-quality exterior acrylic) paint the murals' images on the gridded outdoor wall. A two-inch by two-inch square on the color copy of the scale model equals a two-foot by two-foot section on the wall. Often the artists transfer a gridded line drawing of the scale model to the wall by using an overhead projector after sunset.

Kathleen Farrell
September 15, 2000

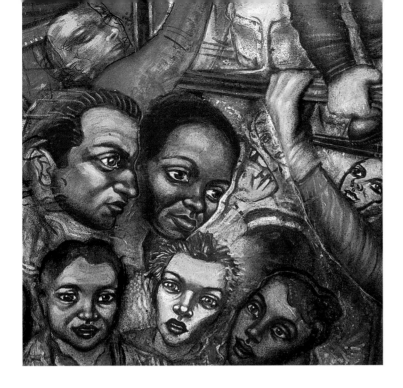

lations to which they belong.

The schism between art and the public has never been greater than at the beginning of the 21st century. Art has never appeared less necessary, and the artist has never been so alienated from society. But this unnatural situation is beginning to change. Starting in the 1960s, community-based public artists worked in cities around the country to reunite artists and communities.

For the Friends of Community Public Art, in Joliet, Illinois, a not-for-profit association, the goal is to revive public art by renewing and revitalizing links among local artists, civic and political figures, and the general population. The fact that local authorities support the association constitutes proof that they see the need to invest in public art as a way to express the ideals of the community and enrich its environment.

FCPA is dedicated to reflecting the entire community of Joliet, including its economic, ethnic, and racial diversity. The organization's founders and members believe art is the ideal vehicle to transform society from within. Without this projection by society into the future, humanity would remain stuck in a colorless world of material struggle, never going beyond the

E ven a brief look at world art history over the centuries illustrates the vital link between artists and the societies they represent. We understand diverse civilizations by studying and enjoying the great works of art and architecture they have created. It is a relatively recent (less than two centuries old) and local (Western Europe and North America) phenomenon that so many contemporary artists find themselves outside society, deprived of the means and capacity to assume their historical role as voices for the beliefs and aspirations of the popu-

A Revelation of Cultural Identity

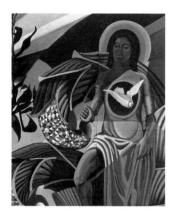

most basic physical level of existence. Martin Luther King's simple and unforgettable statement, "I have a dream," embodies this concept. Humanity advances by dreaming itself forward, and art is one of the most efficient vectors of this phenomenon. Without art, humanity survives but cannot prosper. The existence of art and its support by the population are symbols of the vitality of the inner impetus toward fulfillment within a society. All human beings, rich or poor, need aspirations to give meaning to their lives—without it, society would perish from within. The role of art is to take these aspirations from a latent impulse and translate them into physical form to be shared and used as a source of continued inspiration for all.

The unflagging efforts of FCPA to raise the level of cultural awareness in Joliet have been fruitful. Great progress has been made in mending the schism between artists and the public. This new partnership has allowed the association's artists to learn and apply basic principles needed to promote the appreciation and material support of the visual arts.

To support art, a population must recognize personality and uniqueness within the art form. If the people do not identify with the artwork, no sense of belonging will develop, and the artwork will be seen as generic and unnecessary. This sense of belonging and identification is vital; the aspirations of the public—its most productive and positive aspects—must be represented so that the desire for ownership can emerge.

Another essential element in the nurturing of public art is the quality of conception and execution. Through FCPA, mural participants were privileged to receive a conceptual and technical education that guaranteed the quality of content and expertise of execution. What was created can be considered a school of painting, the result of constant communication among a number of artists, all striving to collaborate at the highest possible level. The "Joliet style" is as recognizable and definable as other schools of painting in the history of art. These schools develop when artists, grouped together by an affinity of ideas, influence each other. In the most recent schools of painting, artists met and worked together in the informal situation of a shared studio or workspace. In Joliet, the shared space was not only the interior of a studio, but also the city itself. The artists had the exciting experience of sharing their discoveries and efforts with the community in a very immediate fashion. The public was both spectator and actor in a contemporary art movement while it was happening.

Joliet was ripe for a new vision of itself. Because of a lack of knowledge about its history, the city's image had suffered, and many people thought Joliet was not a very interesting place. It

was more a place where one "ends up" rather than a place one would choose to live. As artists began researching the city's history, they discovered an endless number of dramatic and exciting stories that people were delighted to share concerning their ancestors. These stories served as raw material for the elaborate works of public art in this book. The community's cultural identity, invisible before the public art program, started appearing on the exterior walls of the urban environment. It soon became apparent that Joliet was no ordinary place and that the stories the city had to tell were exclusively its own.

The development of public art in Joliet has spurred a profound transformation in the local mentality, one that is rapidly evolving. The opportunity for people to contemplate their history and heritage in a lively, colorful visual form has provided an educational tool with which to build for the future. People are often surprised that their personal histories can serve as subject matter for a work of art. They need to be reminded that people like themselves who are willing to get involved in the daily life of their communities can leave their mark on history. They need to be reminded that individuals can make a difference if they can see themselves as capable of making positive changes. And they also need to understand that our urban environment is our collective work, reflecting what we are and how we see ourselves.

Mural paintings, sculpture, and mosaics may appear like miniature postage stamps, lost in the urban environment. But as they proliferate, they have an overall effect that alters our existence in a positive way, just as every person who puts a flower pot on a windowsill makes a small, yet appreciable, gesture toward making our daily lives more poetic. As attention to the environment awakens, and people begin thinking in terms of seeing not only their homes but also their neighborhoods and entire city as belonging to them, then a great transformation can take place. As the city gets "dressed up," its inhabitants start seeing themselves differently, too. The exterior environment reveals how people feel about themselves. If inhabitants make efforts to enhance their urban surroundings, they are giving form to their desire for inner refinement. As individuals reflect their environments back to the community, it creates and reinforces a sense of pride and dignity of belonging to a special, unique place.

If FCPA was afforded space and material support to create lasting works of public art in Joliet, we can assume that other cities would recognize a need for similar programs. All it would take is a few enlightened and devoted minds to put the wheels in motion. It is our hope that Joliet's example will inspire other cities to awaken their innate need for environmental enhancement and education through the revelation of cultural identity.

Chapter One
1999

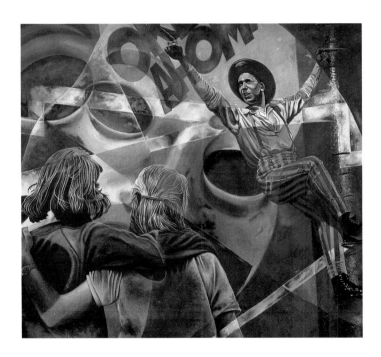

1

The Foundation of Every State
Is the Education of Its Youth:
Joliet Township High School
Centennial Mural 1999

North wall of East Jefferson
Street between Eastern Avenue
and Richards Street

14' H x 296' W
acrylic on concrete

Lead Artists:
Kathleen Farrell,
Thomas Manley,
and Kathleen Scarboro

Assistant Artists:
Dante DiBartolo,
Nicole Brints-Viner,
and Andrea Rountree

This ambitious mural, among the city's largest, is located across the street from Joliet Central High School. It literally reflects the history and architecture, the arts and sciences, as well as the academic, athletic, and cultural accomplishments of one of the most storied and visually striking high schools in the nation. The imposing castle like structure was originally built in 1901 with Joliet limestone.

The mural's three sections, or groups of images—roughly representing history, science, and culture—are connected by abstracted shapes recalling Joliet Central's familiar crenellated parapet, as well as by a gold ribbon which contains a quote from Greek philosopher Diogenes: "The Foundation of Every State Is the Education of Its Youth." This quotation is inscribed on the proscenium arch of the school's auditorium and is well known to students. The colors and symbols of each of the four institutions historically associated with the school system (there are now but two) are also woven throughout the mural (Joliet Central: Steelman; Joliet West: tiger; Joliet East: crown; and the

Joliet Township High School Centennial

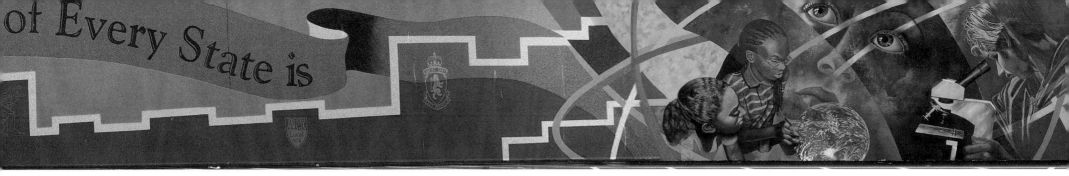

logo of Joliet Junior College).

The first section, on the left, represents early history. Along with the school's ivy and architectural features are images of a man with an old-fashioned bicycle; a view of the high school door with quatrefoil motif; a 1924 string quartet featuring Albert Dunham, a black man who later received his Ph.D. from the University of Chicago; the 1907 girls' basketball team; and a boy in the ROTC program, which had been established at the school in 1919.

The middle section represents scientific pursuits. Girls study a globe, which is the earth as seen from outer space. A girl looks up at the starry night sky as a boy gazes into a microscope. The images are encircled by orbiting bands of color that trace the trajectory of an electron around the nucleus of an atom.

The third section, on the right, represents artistic and other academic endeavors. Wrought-iron lanterns, designed to harmonize with the building's Gothic style and limestone, are installed outside the auditorium entrance. The comedy and tragedy masks represent theater; included is a scene from *Oklahoma!* Two girls express friendship; another girl ponders a pile of books, a picture of learning. The final scene pays tribute to the high school's nationally award-winning band.

Joliet Central's history dates to 1899 with the establishment of the Joliet Township High School district, the second in Illinois. Under the direction of Judge A. O. Marshall, president, the school board selected Joliet architect Frank Shaver Allen to design the city's first public high school building. Envisioning the structure as a "palace of learning and culture, somewhat in the nature of a museum," Allen built the school in Tudor Gothic style, using for the exterior Joliet limestone with a Bedford stone trim. Imported Italian marble was used for the halls and stairs. A Swiss wood carver was brought to this country to design the solid oak doors and entrances with traditional Gothic arches. The building was listed in the National Register of Historic Places in 1982.

The eight-acre campus—which cost over $220,000—was

The American Federation of Teachers Union logo honors JTHS's teachers.

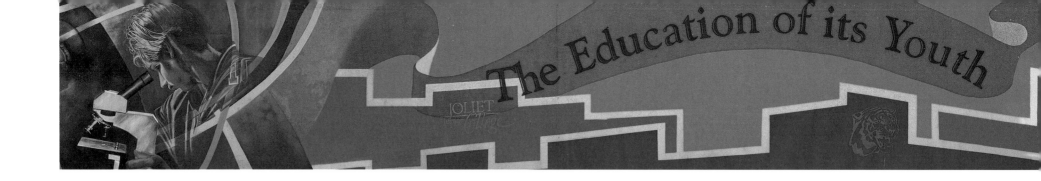

The Education of its Youth

ARTIST BIOGRAPHY

Kathleen Farrell

Born: Chicago, Illinois 1949

Education/Experience: M.F.A., printmaking,
L'École Nationale Supérieure des Arts Décoratifs,
French Ministry of Culture, Paris, France, 1978;
M.A., cultural anthropology, Governors State
University, 1975; B.A., painting, Southern Illinois
University, 1971.

Current status: studio painter, sculptor, and
mosaicist specializing in art for labor unions.
FCPA artist and administrator, Joliet, Illinois.

As much as I love to create art, I love to promote the love of art in others. I strongly believe that visual art can have a profound effect on the way a population feels about itself, which ultimately can transform the collective culture of that group. The community and labor union public art I create tells the often forgotten stories of the lives of ordinary people—their history, struggles, and hopes. I strive, through my art, to bring beauty and power to their stories.

Katth Farrell

dedicated in April 1901. Allen donated the seven-foot statue of Abraham Lincoln that now stands near the Jefferson Street entrance; it was the first of many original artworks—murals, paintings, friezes, and sculptures—to embellish the school's interior. These included (in 1905) a series of ten mural panels by William Penhallow Henderson depicting the Marquette and Joliet expedition.

Joliet Township's opening enrollment was 581, which included five students who were doing post graduate work in the school building. The special advanced science courses offered since 1901 formed the nucleus of the junior college movement. In 1916, the college assumed the name Joliet Junior College, the oldest public community college in the nation. It was operated by the high school district until 1967 and two years later was relocated to its present location on Houbolt Road.

Joliet Township's student population grew rapidly, due to the prosperity and expansion of the city. By 1915, enrollment surpassed 1,000, and building additions became necessary. Four extensions were added between 1917 and 1931, all designed by the D. H. Burnham and Company of Chicago. The 1917 sec-

16

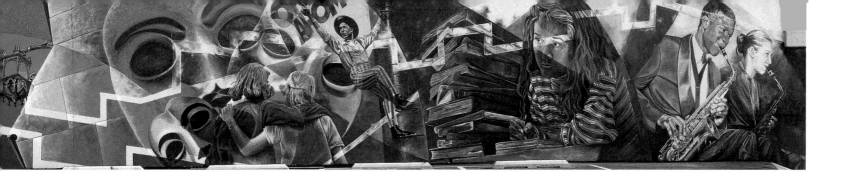

tion, which housed Joliet Junior College, increased the size of the building by fifty percent. Subsequent additions included a boys' gymnasium, a girls' gym, and (in 1924) a 2,100-seat auditorium. The auditorium incorporated mural decorations by Chicago artist Frances Badger and the Diogenes quotation on the front ceiling.

During the 1920s, when enrollment topped 2,000, Joliet Township continued to broaden its academic program. By 1930, it was ranked the fourth best high school in the nation. Joliet Township excelled in many other areas, especially the music program. The band, organized in 1912 and for more than three decades under the direction of famed bandmaster A. R. McAllister, was known as the best in the nation by the late 1920s. It would go on to win dozens of national, state, and regional band championships, earning Joliet the name "City of Champions." The orchestra has also excelled, winning numerous awards and sending many of its alumni on to distinguished careers in music.

In 1932, former Joliet Township student Louise Lentz Woodruff designed an aluminum sculpture that would become

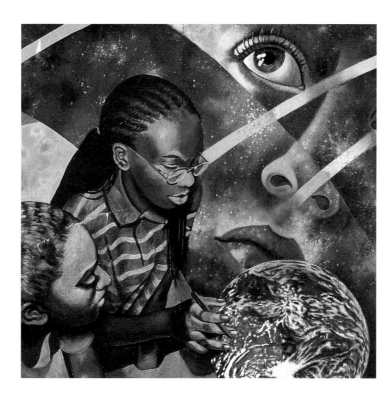

The artists often develop portraits in monochrome.

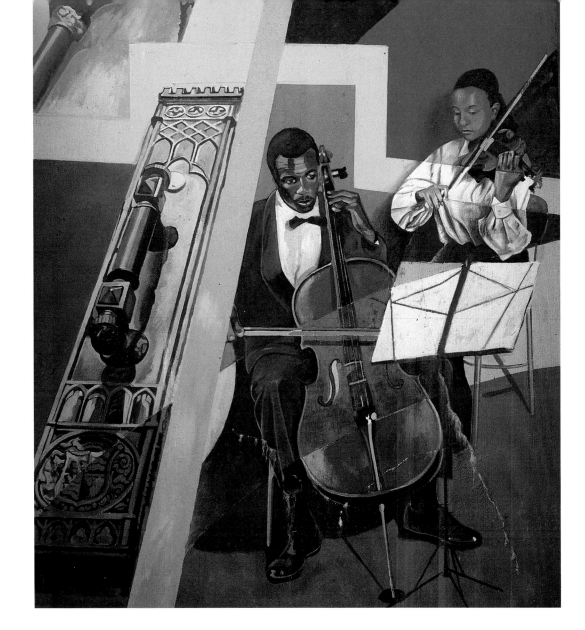

JTHS students Xavier Atkinson
and Nina Crudup posed as members
of the school's 1929 String Quartet.

the school's symbol. The work, *Science Advancing Mankind*, depicts a robot-like figure leaning into the future, flanked by male and female figures. It was the official symbol of the 1933–34 Century of Progress World's Fair in Chicago. Woodruff donated the sculpture to the school in 1935, and students named it the *Steelman*. The piece was refurbished and relocated in 1985. (Woodruff gave a second sculpture to Joliet Central in 1965, that depicts a steelworker holding a large dipper like tool. Her name for the bronze was *Steelman*, but students called it the *Puddler*.)

After 1935 Joliet Township's athletic teams were known as the Steelmen. Over the years they have won many tournaments and trophies. Their greatest achievement came in 1937 when cagers won the Illinois state high school basketball title, defeating Decatur with a score of 40 to 20. The school has also excelled in baseball and wrestling. Grapplers took the state wrestling championship in 1985.

The 1950s were also banner years for Joliet Township. In 1953, the physics department bought a planetarium for $2,000—the first high school in the nation to do so. It features the Joliet skyline painted in black. The school also owns an observatory, originally installed with a wooden dome in 1906. It was replaced in the 1950s with a metal one. Because of the com-

FCPA artist Dante DiBartolo posed as a member of the 1919 School ROTC.

ARTIST BIOGRAPHY

Nicole Brints-Viner

Born: Lubbock, Texas 1969

Education/Experience: B.F.A., design communications, Texas Tech University, 1993; studied photography, Plymouth University, Exeter, England, 1992; decorative mural painter, Texas and France, 1993-1995; specializes in trompe l'oeil and representational mural work

Current status: mural painter; FCPA artist, Lockport, Illinois.

Painting murals is my way of contributing to the education and awareness of the public, while also creating a piece of work that expresses its subject matter and becomes an artwork that a community can call its own.

prehensive nature of its classroom offerings, Joliet Township was extensively used as a study source for three books published in the 1950s about American high schools.

The student population peaked at 9,000 in 1963. Conditions had become so overcrowded that teachers and students attended school from 7:30 a.m. to 5:00 p.m. To alleviate the problem, the district built two very modern schools, East Campus on Mills Road and West Campus on Larkin and Glenwood Avenues. Both opened in September 1964, though Joliet East closed in 1983.

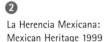

La Herencia Mexicana:
Mexican Heritage 1999

South wall of 617 North
Collins Street

10' H x 36' W
acrylic on sign board

Lead Artist:
Jesus Rodriguez

Assistant Artist:
Ilario Silva

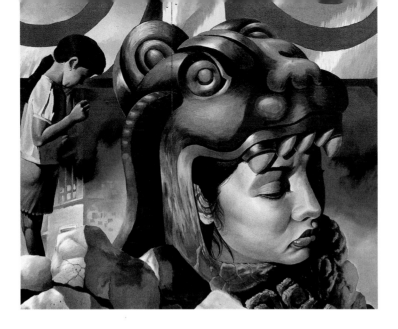

This mural highlights the history of Mexican-Americans in Joliet. It presents a montage of scenes—literal and symbolic, with key events and figures—signifying the struggles and aspirations of succeeding generations, from early immigrants to today's youth. The painting's design derived from a series of questions: What does it mean to be a Mexican living in Joliet? Who were the first to come here, and why? What was life like here in the past, and what will it be like in the future? (This artwork occupies the site of the previous Mexican heritage mural *La Imagen de Uno*, also by Rodriguez.)

The mural opens on the left with an image of an Aztec eagle warrior, the highest status accorded to men in the *Azteca* (or *Mexica*) empire that flourished in the Valley of Mexico from the early 14th to early 16th centuries. Aztec warriors are symbols of a strong cultural heritage. Just beneath are construction beams, representing the Joliet steel mills where many Mexicans found work beginning in the 1940s. The two images forge a link between the heroism of an ancient past to the working-class heroism of the modern day.

The Mexican-Indian mothers with infants refer to the migration to the U.S. that began in large numbers in the 1920s. In Joliet, railroads such as EJ&E and the Santa Fe were an early source of employment for the Mexican community; they hired migrants as inexpensive labor to lay tracks and work in the yards. Some workers lived with their families in boxcars during the 1920s and 30s, a scene pictured here.

The photographs at the center depict Joseph Belman and Sandy Sanchez, among the many Mexican-Americans in Joliet (and elsewhere) who were proud to fight for their country during World War II. Sator "Smilin' Sandy" Sanchez is known for having a B-17 bomber named after him.

The scene of demonstrators marching with placards refers to

La Herencia Mexicana

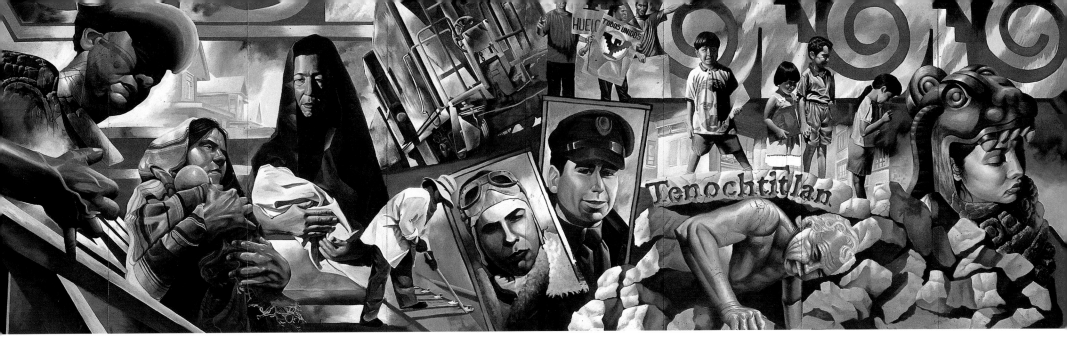

a boycott that took place in Joliet at the A&P supermarket on Cass Street. During the United Farm Workers' (UFW) movement of the late 1960s and 70s, union leader Cesar Chavez organized Mexican migrant laborers to fight for better wages, benefits, and working conditions. The UFW adopted the black eagle as a symbol. Though the movement was based in California, farm workers and other citizens throughout the U.S. boycotted supermarkets that sold nonunion produce.

With pre-Columbian designs as a backdrop, the mural's final scene shows a group of children standing above the ruins of Tenochtitlan, the powerful capital of the Aztec empire. The ruins are supported by an older man who represents the wisdom and knowledge of preceding generations. The message is that elders, parents, and teachers must try to help the younger generation confront, overcome, and learn from the struggles in their lives. By doing so, the young can build from the hopes and dreams of the past and form a bridge to future generations. The closing image on the right is that of an Aztec jaguar woman.

According to *Sintesis Historica de la Colonia Mexicana de Joliet, Ill.*, a small book published by longtime resident and civic leader Navor Rodriguez, Mexicanos from Mexico and the Southwest U.S. had been coming to the Joliet area as early as

The artists's family members posed as characters for the mural.

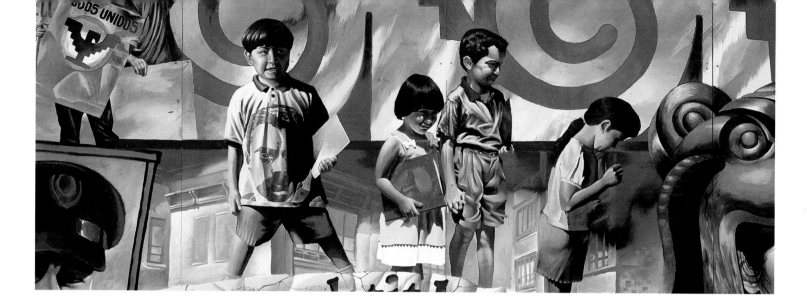

The artist's son has an image of Emiliano Zapata on his shirt.

1905 to work as agricultural laborers. But permanent settlement did not occur in significant numbers until after 1914, during World War I. The earliest family names recorded were Sanchez, Orozco, Elilzalde, Rivera, and Quiroz. The first births and deaths occurred in 1916–17. By the early 1920s, Joliet's Mexican-Americans had begun to form social clubs, mutual aid societies, and fraternal and religious organizations.

The history of Mexicans and other Latinos in Joliet is closely related to that of Our Lady of Mount Carmel Church. The church began in 1939 when Reverend Matthew O'Neill, pastor of St. Mary Carmelite Church in downtown Joliet, realized that Mexican Catholics needed a place to worship in their own language. He purchased a storefront on Collins Street in the heart of the city's East Side Mexican community. Soon a new building became necessary, and a decade later, in May 1949, the current Our Lady of Mount Carmel Chapel was formally dedicated.

For more than a half-century, the church has functioned as the center of religious, immigrant, social, and cultural life of the Hispanic community in Joliet. The founders who arrived in increasing numbers during the 1920s to work on the railroads; the post-World War II immigrants who came to work in agriculture and industry; the Texans and immigrants from San Luis Potosi, Jalisco, Michoacan, Guanajuato, and other areas; the recently arrived; the undocumented—all have been received by Mount Carmel.

Father Victor Lopez, the first Mexican-American priest to be assigned to the Chapel, served and lived in the community from 1971 to 1978. Among his accomplishments was the commissioning in 1975 of Chicago artist Ray Patlan to paint in the Chapel interior, the first Mexican mural in Joliet, O *Rising Sun, Sun of Justice*.

St. Mary Carmelite Church, the mother church of the Chapel,

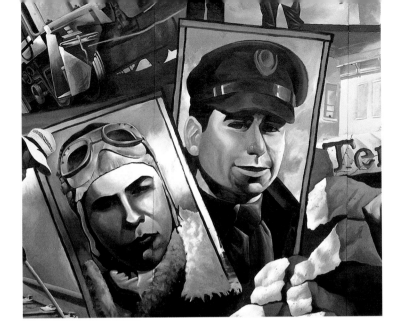

World War II heroes
Sator Sanchez and
Joseph Belman are honored.

was closed in 1991, and shortly thereafter Our Lady of Mount Carmel was decreed a new parish. Father Raymond Corkery, the current pastor, arrived in 1995. To serve the growing spiritual and social needs of the community, he is currently shepherding the construction of new church facilities to be located at 205 Jackson.

The Spanish Center, a nonprofit organization, was founded in 1969 in the living room of Pedro and Patricia Hernandez, Mount Carmel parishioners, at Herkimer Street. Initially functioning as a distribution center for the material needs of Mexican migrants, the center has extended its services to all people. The facility has evolved into a multiple service center in the areas of medical need, welfare, law, education, youth activities, social services, counseling, and civic events. The Spanish Center moved to its current location on Eastern Avenue in 1985.

ARTIST BIOGRAPHY

Ilario Silva (left)

Born: Joliet, Illinois 1979

Education/Experience: study at American Academy of Art, Chicago, Illinois.

Current status: student, FCPA artist, Joliet, Illinois.

Jesus Rodriguez (right)

Born: Morelia, Mich, Mexico 1972

Education/Experience: completed studies at American Academy of Art, Chicago, Illinois 1994.

Current status: master tattoo artist, FCPA painter, muralist, and mosaicist, Joliet, Illinois.

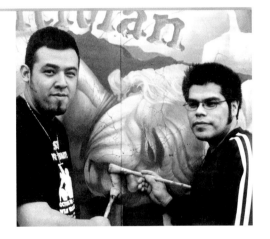

Through mural painting, art becomes a part of the landscape. People live and react with it every day. —I. Silva

Emotional content! —J. Rodriguez

3

Ancient Traditions, A New Frontier:
An Italian Heritage 1999

North wall of 121 North
Chicago Street

25' H x 18' W
acrylic on sign board
and concrete

Lead Artist:
Kathleen Scarboro

Assistant Artists:
Kathleen Farrell
and Nicole Brints-Viner

This inventive mural honors the contributions of Italian-Americans to the Joliet area. Composed of five panels that recall a Roman building facade, many of the artwork's images are drawn from Italian Renaissance sources, such as the *trompe l'oeil* Ionic pillars and pediment, and paintings by Caravaggio. The piece unites formal technique and subject matter.

The panels, connected by flowing drapery that also recalls Italian painting, portray the various traditions of art, architecture, music, and cuisine that Italians brought to Joliet at the turn of the century, enriching their lives and the community as well. The mural's faux architectural features elegantly play off of the Italianate facade of the Rialto Square Theatre, located across the street. The building's decorative elements were crafted by Italian artisans in the 1920s.

Moving counterclockwise: the right panel depicts an Italian village, not unlike the small towns to which many of Joliet's Italian-American citizens can trace their roots. Inset is the great tenor Enrico Caruso, costumed as Duke in the famous Giuseppi Verdi opera *Rigoletto*. Caruso sang in Joliet several times, including a 1911 performance at St. Anthony's Church.

An Italian Heritage

The top panel shows an immigrant family, full of courage and hope, embarking on a new life in America (in each panel, a sky-blue area symbolizes the New World). Northern Italians began immigrating to Will County in the 1870s to work in the coal mines of Braidwood and Coal City; by 1900 they formed the majority of the work force. When the mines began playing out by the 1920s, families moved to Joliet's southeast side and found work as limestone quarrymen, streetcar workers, laborers, plasterers, and cement finishers. Many Southern Italians settled around Meeker and Chase Avenues on the city's northeast side. They included skilled building tradesmen such as carpenters, plasterers, and cement finishers.

New immigrants continued to arrive through the first half of the century. Sacred Heart Church on Ottawa Street and St. Anthony's Church on Scott Street served the Italian community, as did fraternal organizations and social clubs, which helped support the families of workers killed or injured on the job.

The left panel depicts a view of the Rialto Square Theatre. Named after a bridge in Venice, the Rialto was among the many

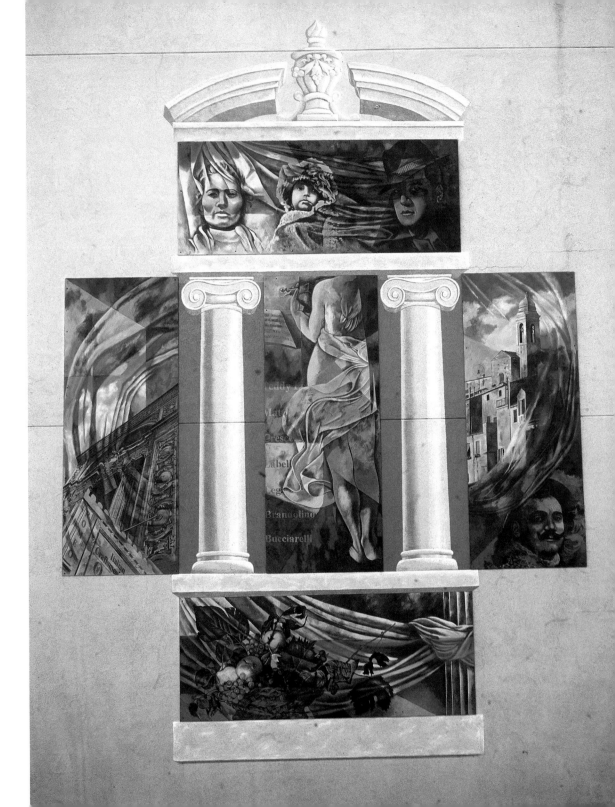

Kathleen Scarboro

Born: Chicago, Illinois 1950

Education/Experience: M.F.A., printmaking, L'École Nationale Supérieure des Beaux Arts, French Ministry of Culture, Paris, France, 1978; B.A., painting, Southern Illinois University, 1974; collaborated with Kathleen Farrell since 1977.

Current status: studio artist specializing in painting everyday life in India and islands in the Indian Ocean. FCPA muralist, mosaicist, and sculptor, Joliet, Illinois and Paris, France.

Creating art has given direction and meaning to my life for as long as I can remember. To me it is synonymous with being alive—it is my chosen path to personal evolution. I feel fortunate to have been able to express myself in this way and hope that my efforts enrich not only my life but also the lives of all those for whom I work—the various populations who have provided an infinite source of inspiration and motivated me to continue my work over the years.

grand movie palaces designed by architects C. W. and George Rapp. In 1920, master artisan Eugene Romeo came to Joliet from Italy with a crew of skilled craftsmen to create the theatre's lavish decorative details. The "Jewel of Joliet" opened in 1926 and for years was one of the premier movie-houses in the nation. Its marquee features emblems of the three unions whose locals had a large Italian-American representation: the Operational Plasterers and Cement Masons (Italians established the local chapter in 1899); the Laborers' International (its local #75 was founded by Tony Agostino in 1913); and the United Mine Workers (whose forerunner had been founded in Braidwood).

Before the 1930s, Italian workers—like other immigrant groups—frequently worked long hours at low pay and in dangerous conditions. The unions they helped organize fought not only for improved pay and working conditions, but also promoted legislation protecting the families of working men and women. The unions lobbied for free public education, workmen's compensation, and laws outlawing child labor. Italian women worked in neighborhood groceries and bakeries, as well as in factories.

The bottom panel, showing a still life of a basket of fruit with

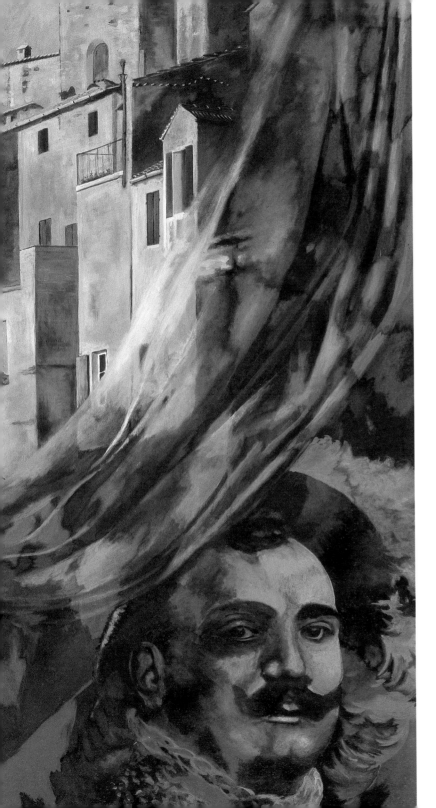

grapes, was inspired by a Caravaggio painting. It illustrates the importance of traditional food and cookery to Joliet's Italians. Many families grew large vegetable and herb gardens, the produce of which was used in age-old recipes. They made wine, bread, and sausages, and opened bakeries and grocery stores that stocked Italian favorites. One of the originals, Milano Bakery, is still operating on South Chicago Street.

The mural's classical centerpiece shows an angel playing a violin, an image also drawn from a Caravaggio painting. It is a tribute to the many Italian-American musicians who have enhanced the quality of life in the Joliet area, going back to the Giuseppe Verdi Band formed by Will County coal miners earlier in the century. Italian boys were encouraged to learn the accordion and to participate in school bands and orchestras. Many would become professional musicians—Brandolino, Bucciarelli, Caneva, Crescenti, LaBella, Lega, and Mattei are just some of the names associated locally with music.

This mural is also a tribute to its sources. Designer Kathleen Scarboro—whose grandparents emigrated from Italy in the late nineteenth century—and painter Kathleen Farrell have been inspired by classical Italian art throughout their careers.

Enrico Caruso performed at Joliet's St. Anthony Church in 1911.

In 1920, Italian plaster artisans created the elaborate decorations in the Rialto Theater.

28

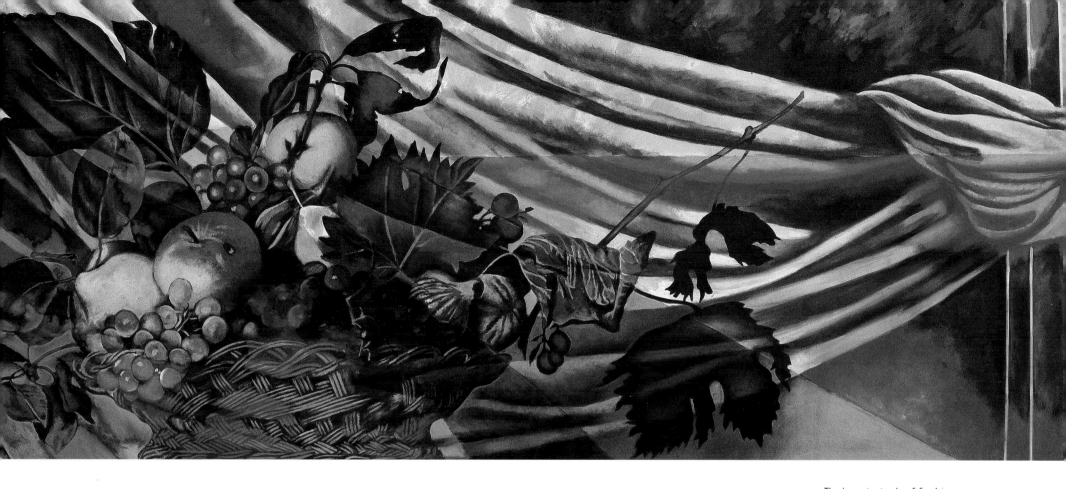

The important role of food to
Italians, from growing herb
and vegetable gardens to its
preparation, inspired this image.

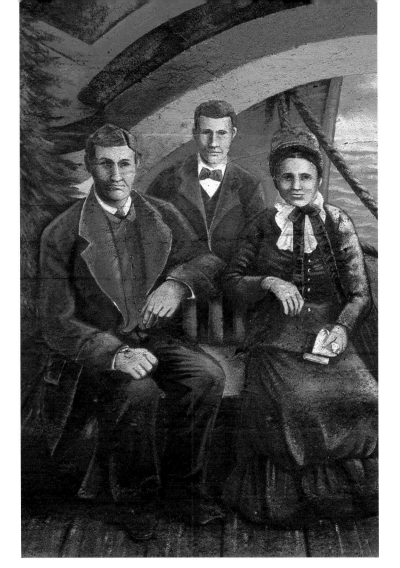

④

German Heritage
Part I 1998

South side of Columbia Street
at Scott Street

10' H x 35' W
acrylic on concrete

Lead Artists:
Thomas Manley
and Dante DiBartolo

Assistant Artist:
Erin Jordan

This mural reflects the influence of German immigrants on the Joliet area. Its design recalls successive images from a photograph album, connected by a flowing banner of the German national colors, then becoming the red, white, and blue of the American flag.

The first set of images, on the left, depicts the rocky terrain, pasture, and a traditional farm building from the Oldenburg region of northern Germany, where many of Joliet's Germans can trace their roots. A *Jungfrau* is shown sitting on a stool, milking a cow. A recurring motif in the mural is that of the *Tannenbaum*, the fir tree esteemed by Germans everywhere. In the center, family members are seated on a dock with their luggage, waiting to set sail across the ocean to the New World. (The family's images are based on photographs of muralist Thomas Manley's great-grandparents.)

The first German settlers in Joliet were George Erhard and John Belz. They arrived in 1836 and established a brewery two years later, the first in the city. The next group of images refers to St. John the Baptist Catholic Church, the oldest German parish—and church—in Joliet. It was founded in 1852—the

German Heritage Part I

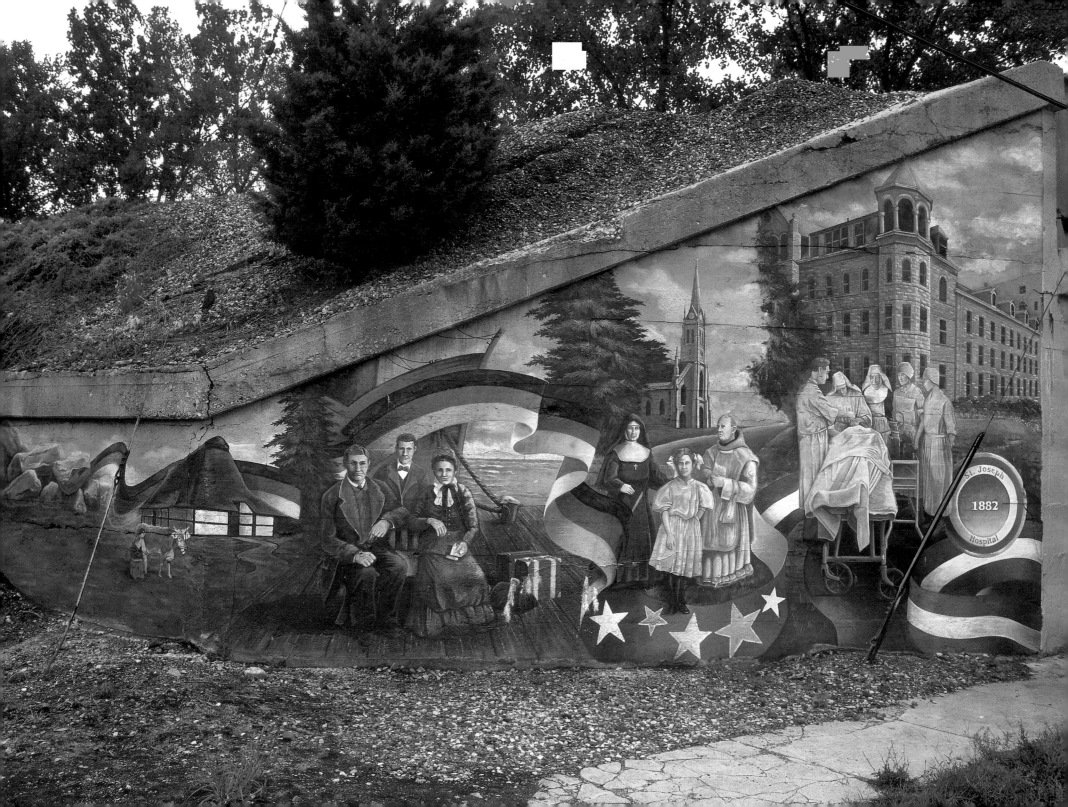

The picture, circa 1905, shows Mr. Manley's mother as a young girl with her older sister.

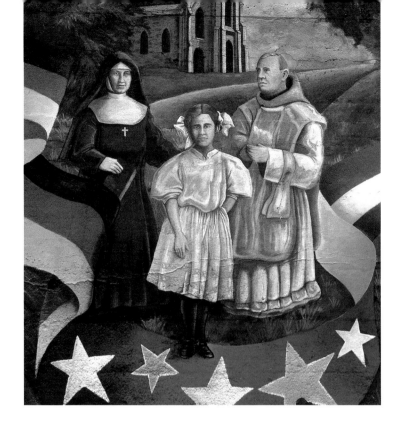

same year Joliet incorporated as a city—by about forty families, including those of Erhard and Belz. Pictured here is St. John's second church, completed in 1866; it is still used today by many of the original parishioners' descendants. (The founding of Joliet's first German Lutheran church is part of *German Heritage Part II*.)

St. John's became a Franciscan parish in the 1870s. The Franciscans were one of many religious orders expelled from Germany beginning in 1858 during Chancellor Otto von Bismarck's *Kulturkampf*, or "struggle for culture." The largest

contingent of friars came to America in 1875, settling in Teutopolis, Illinois. A year later, St. John's was one of twelve parishes placed under their care. In 1877, the friars arrived in Joliet to take up residence at the church, where members of the order remain to this day.

Since 1863, children of St. John's had been educated by the Franciscan Sisters of Mary Immaculate, who soon established their motherhouse in Joliet. St. John's was the first mission of their newly founded order. In the space of one generation, the sisters took the children of immigrants and turned them into cit-

izens. Just below the image of the church is the scene of a young girl in a communion dress (Manley's mother) standing between a Franciscan sister and priest. At this point in the mural, the unifying banner changes into the Stars and Stripes, signifying American assimilation.

The final set of images, on the right, refers to St. Joseph Hospital (now the Provena St. Joseph Medical Center), and the Franciscan Sisters of the Sacred Heart, who left their homeland for America in 1876, also victims of the *Kulturkampf*. Four years later, three sisters were called to Joliet to care for those who had fallen ill during a severe typhoid epidemic. It had scarcely subsided when smallpox swept the city, and more sisters arrived. When this epidemic ended, the citizens of Joliet showed their appreciation by donating $600 toward the building of a hospital. In 1882, the Franciscan Sisters of the Sacred Heart moved into the convent vacated by the Franciscan Sisters of the Immaculate Conception and expanded it to become St. Joseph Hospital, shown in the mural.

Also depicted is a hospital operating room scene from the late 1920s featuring Dr. Charles Curtiss, a well-known physician and surgeon. The design of the medallion is based on that of the pin worn by graduates of the School of Nursing, founded at St. Joseph Hospital in 1920.

Tom Manley

Born: Joliet, Illinois 1937

Education/Experience: M.A., art education, Illinois State University, 1966; B.S., art education, Illinois State University, 1959; specializes in liturgical art.

Current status: fabric artist and art teacher at Joliet Township High School's Central Campus, FCPA artist, Joliet, Illinois.

As an art teacher for many years, my art has been largely of a vicarious nature, coming to life in the work of my students.

Studio art has always had an aura of pointlessness for me. Working in a program of public art is a purposeful endeavor. I am very excited to be a part of this important, far-reaching project.

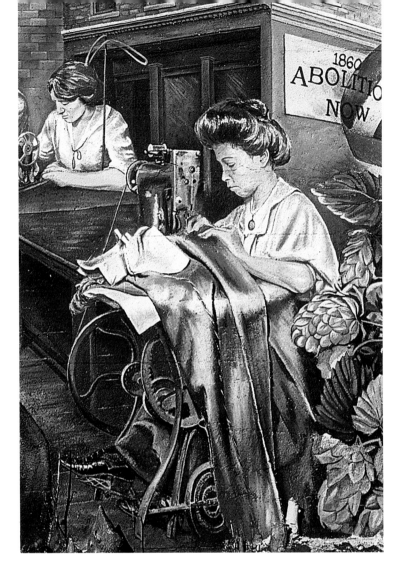

5

German Heritage
Part II 1999

North side of Columbia Street
at Scott Street

10' H x 35' W
acrylic on concrete

Lead Artists:
Thomas Manley
and Dante DiBartolo

Assistant Artists:
Andrea Rountree,
Nicole-Brints Viner and John Betkin

This mural continues the visual narrative of Germans in Joliet. While the first mural focused on immigration and assimilation, this painting—rendered in a lighter, looser tone and style—presents a lively, teeming portrait of German-American life in the early twentieth century. Beribboned by the U.S. flag's colors, the artwork portrays the extent to which first- and second-generation German families actively participated in the business, civic, and social life of the community.

Topping the mural is an image of St. Peter's Lutheran Church. In May 1857—five years after the establishment of Joliet's first German Catholic parish—a group of immigrants formed the German Evangelical Lutheran St. Peter's Congregation and work soon began on a frame church. The present church was dedicated in 1884, although the steeple was destroyed by fire in 1916 and a front porch and steps were added in 1924. Reverend Erdmann Wilhelm Frenk, followed by his son Reverend Martin Luther Frenk, together contributed forty-three years of service to the church.

The remainder of the mural depicts turn-of-the-century residents working in factories, running businesses, pursuing trades,

German Heritage Part II

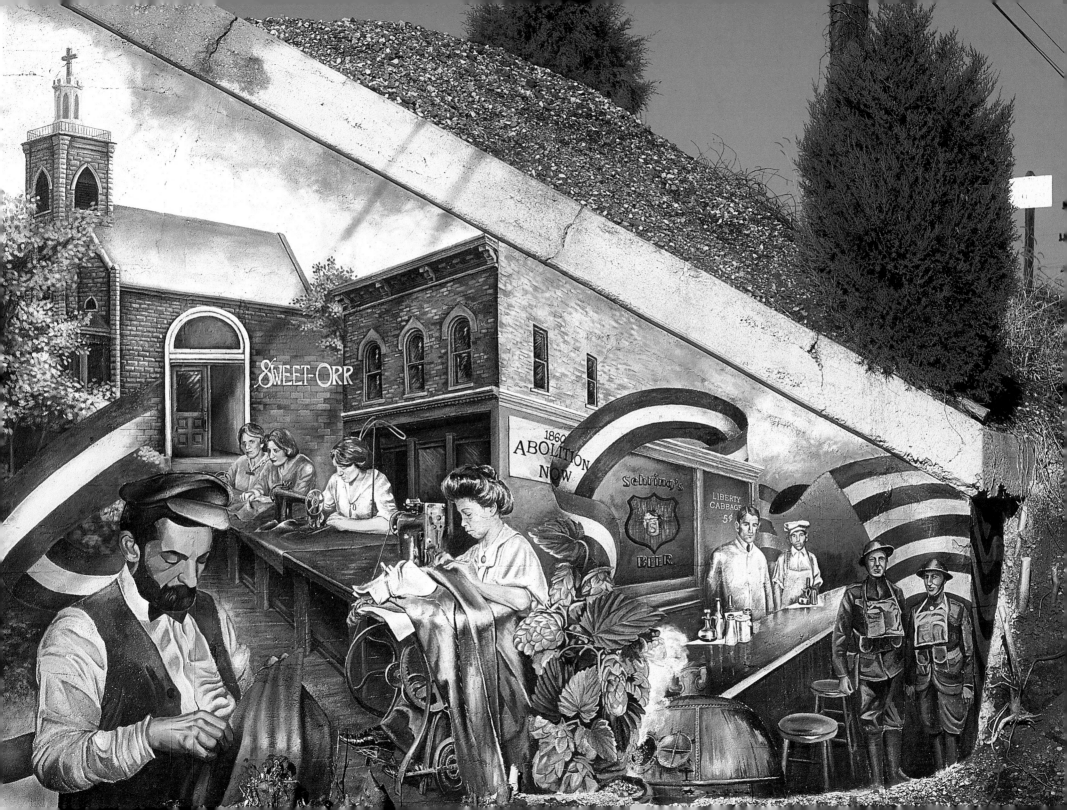

and engaging in other activities. By the 1860s, Joliet claimed a sizable German-born population. They worked as stonemasons, carpenters, butchers, blacksmiths, grocers, brewers, farmers, laborers, doctors, and were also dealers in livestock, lumber, clothing, and shoes. One notable citizen was Adam Groth, who started his own stone-cutting business in the late nineteenth century and helped to build many of Joliet's historic downtown buildings.

Though integrated into the community, a German-American neighborhood could be identified extending roughly from Jefferson Street on the south to Theodore Street on the north, and from Bluff Street on the east to Raynor Avenue on the west. The area included the Lutheran and Catholic churches; Germania Hall; businesses such as the Westphal German Savings Bank, grocery stores, butcher shops, and taverns; and residences both modest and grand, including the castle like home of the Sehring family.

The row of seamstresses, depicted at the center of the mural, worked for the Sweet-Orr Company, where hundreds of Joliet women—including many young German women—got their first jobs making men's overalls and other articles of clothing. They were the only female industrial workers to sign union contracts in Joliet in the earlier part of the century, and they enjoyed a good relationship with their employer. The pay was good, and since they were paid by piecework, fast workers could earn more. The factory was located upstairs in a building at Chicago and Webster Streets until the New York-based firm closed its Joliet operations in the 1930s.

In the foreground is a German-Jewish tailor. While Joliet's Jewish community did not seem to make its presence felt before the 1890s, the 1859 city directory lists Solomon Levi—most probably Jewish—as having a tailor shop on Jefferson Street. It is uncertain, however, whether he was also German. In 1878, Daniel Rosenheim and Morris Einstein were purveyors of men's clothing, and although they were undoubtedly German, it is not known if they were Jewish. Not until 1893 did Jews hold religious services, leading eventually to two synagogues that merged into the Joliet Jewish Federation in 1922.

The Fred Sehring Brewing Company was the most well known of three successful German-run breweries at the turn of the century. Its logo of a beer mug overflowing with foamy liquid—pictured here on the side of the Westphal Bank—was a familiar one in Joliet for decades. The sign "Abolition Now" refers to Germans' involvement in the local antislavery movement. Just below, images of hops and a brewing kettle further identify Joliet's Germans with beer brewing.

Near the right, Martha Sievert Murray is shown running her lunch counter in the basement level of the Murray Building at Cass and Chicago Streets; a second-generation German, she was married to Daniel H. Murray. Among other menu items, she served "Liberty cabbage" and, no doubt, "Liberty sausage," as sauerkraut and wieners came to be known during World War I, owing to anti-German sentiments.

The doughboy figures at the right (including one based on an image of muralist Thomas Manley's father) underscore this wrenching conflict, which was a significant turning point for German-Americans, as the sons of immigrants went off to fight the sons of the fatherland. The war effectively brought to an end the German influence on American communities; the teaching of German and the use of the language were discouraged, and German newspapers became politically suspect. (However, St. Peter's continued to conduct services in German until the recent past.) The negative feelings would persist for decades, until after World War II when Germans would be fully woven into the fabric of American life.

Andrea Rountree

Born: Orangeburg, South Carolina 1944

Education/Experience: M.F.A., painting, Northern Illinois University, 1991; M.A., drawing, Northern Illinois University, 1989; B.A., art history, University of Georgia, 1966.

Current status: studio painter, member of the Mythopoeians Art Group; FCPA artist, Joliet, Illinois.

I agree with Thomas Moore that art is essential for the soul; and it is only a society that has forgotten its soul that could marginalize its art and its artists. That the City of Joliet would support an art renaissance like that now taking place in Joliet to me means a sign of material and spiritual abundance.

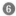

United We Stand: Irish Heritage
1998

North wall of 121 North Chicago
Street at Clinton Street

10' H x 20' W
acrylic on sign board

Lead Artists:
Kathleen Farrell
and Kathleen Scarboro

Assistant Artist:
Nicole Brints-Viner

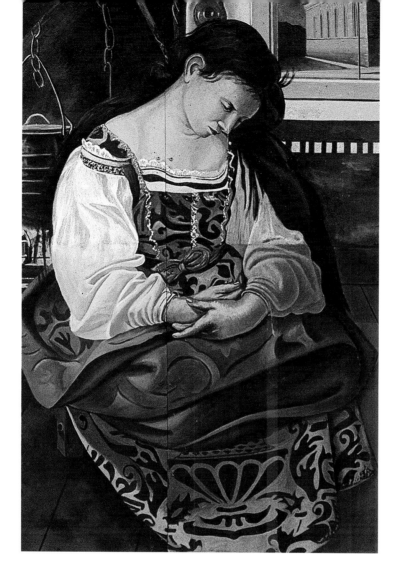

Thisthis mural is a tribute to Joliet's deeply rooted Irish heritage. The montage like painting features realistic details and dramatic reenactments to illustrate, in several key scenes, the story of the Irish Diaspora and the ways in which Irish men and women have contributed to the history and character of Will County since the 1830s.

The upper left side of the mural depicts the harsh living and working conditions in Ireland of the mid-nineteenth century. With simple thatched-roof cottages in the background, women are shown toiling in a potato field, superimposed over a ribbon of the country's orange, white, and green flag. The flag—whose colors form the dominant palette for the entire artwork—signals the transition from Ireland to America, where many immigrants found life as difficult as it had been in the old country.

Even before fleeing the Great Potato Famine of 1846–1851, many Irishmen found work digging the Illinois & Michigan Canal, completed in 1848, and later in local limestone quarries. These industries, represented in the mural by a stonecutter breaking up slabs of rock, spurred the early growth and development of Joliet. The majority of canal workers were Irish, who

United We Stand Irish Heritage

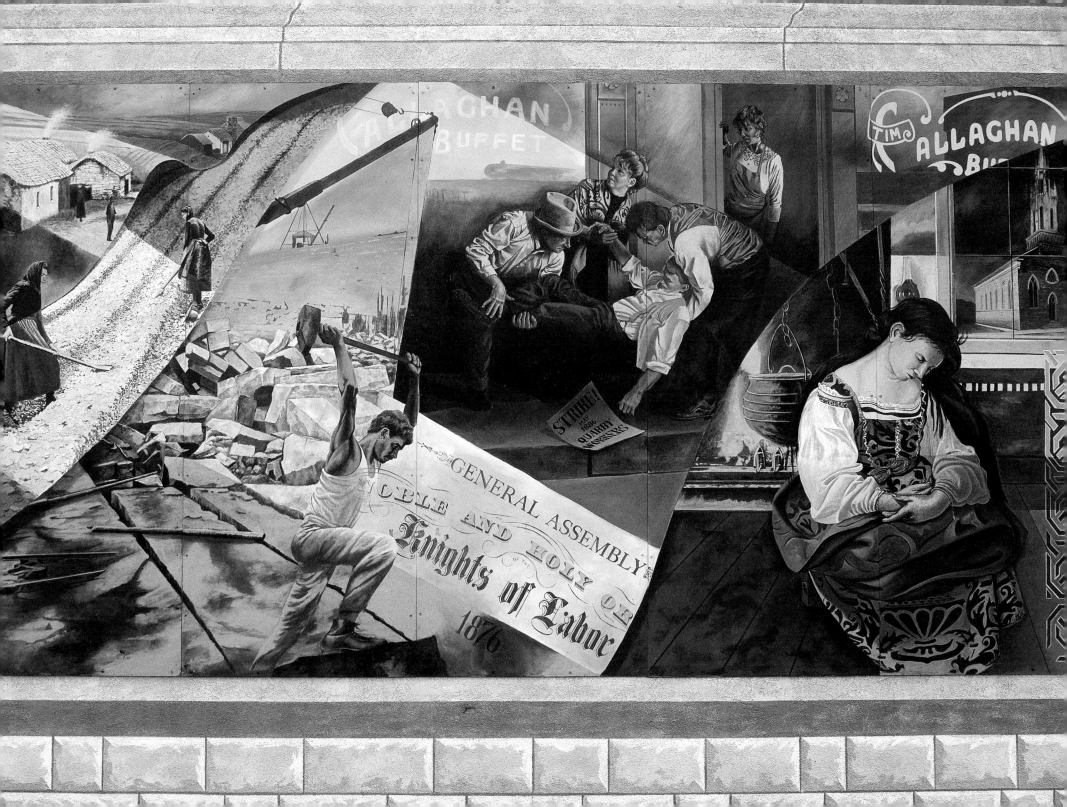

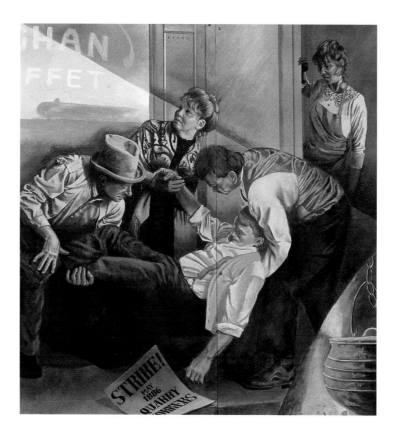

Quarry workers helping a wounded worker during the 1885 quarry stike.

toiled long, hard hours at low pay in dangerous working conditions. They lived in crowded, unsanitary shantytowns, and many died of diseases such as cholera, dysentery, and typhoid fever.

The mural's dramatic centerpiece pays homage to the major role that local Irish played in organizing labor unions and fighting for workers' rights. In 1876, Irish-Americans helped found (in Chicago) the Noble and Holy Order of the Knights of Labor of America, the nation's largest labor organization in the nineteenth century. The Knights' ranks included mostly unskilled, foreign-born industrial workers, farmers, women, and blacks; in Joliet it also represented steelworkers and stoneworkers. The Knights, at the forefront of the Eight-Hour Day Movement of the 1880s, boosted its membership from 28,000 in 1880 to 700,000 in 1886, its peak year. But after the Haymarket Riot and a failed packinghouse workers strike, both in 1886, the Knights' influence and prestige rapidly declined. It was soon supplanted by the organization that would become the American Federation of Labor.

The scene in the upper center of the mural shows striking quarry workers helping a wounded worker into Tim Callaghan's Bar and Buffet on Collins Street in Joliet. In May 1885, quarrymen in Joliet, Lockport, and Lemont—some of whom were

In her studio, the artist photographed City of Joliet employees, wearing period costume.

Irish—went on strike. Clashes with the state militia in the area resulted in the deaths of two workers in Lemont and in many more injuries. (Current local residents of Irish descent posed for this reenactment based on historical sources: from the left, Dave Churchill, Donna Churchill, Bob Charlie as the wounded striker and Bill Fitzgerald.)

Life for Joliet's Irish-Americans was not all toil and struggle. The right-hand section of the mural presents a reflective domestic scene. A woman prays by her hearth as the old St. Patrick's Church can be seen across the street through the window. St. Patrick's, located at the southwest corner of Broadway Avenue and West Jefferson Street, was formed in 1839 by newly arriving Irish and was Joliet's first Roman Catholic parish. The building was begun by Father John Francis Plunkett (who died a year later) and completed in 1848 during the pastorate of Father John Ingoldsby. Just as the Irish helped forge the foundation of a city, this scene is a testament to Irish-Americans' enduring faith in such institutions as home, family, and church.

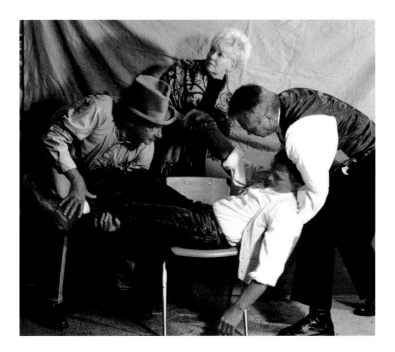

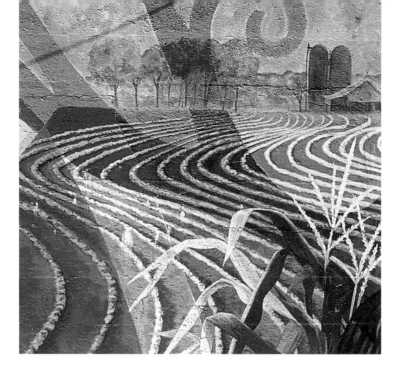

From the Hands of Ceres:
Ode to Will County Farmers
1998

East side of the 500 block
of Scott Street

14' H x 40' W
acrylic on concrete

Lead Artists:
Kathleen Scarboro
and Kathleen Farrell

Assistant Artist:
Dante DiBartolo

This mural honors the life-giving properties of agriculture, as well as area farmers whose labor puts food on our tables. The painting's dynamic, poetic composition moves through time to reflect the cycle of planting, growing, and harvesting, and also evokes the interrelationship of earth, nature, crops, and people. The design is partly inspired by the handmade stained-glass windows that appeared in farmers' churches—an example of the role art has played in the everyday life of Joliet's people.

The mural is dominated, at the center, by the hands of Ceres, the Greek goddess of agriculture, particularly of corn and other grains. She is also the ancient mythological origin of what we refer to as "Mother Nature," which exists in different forms in cultures throughout the world.

Ceres is shown distributing her nurturing seed-grains to grateful farmers, who are surrounded by corn, the major food crop grown in the Joliet area. Farmers are depicted as both the recipients and producers of agricultural wealth; we, the consumers, are grateful for the nourishment they provide us. The interwoven images of corn, figures, and hands, as well as the mural's color scheme—from brown (earth) to green (fecundity) to blue (sky)—signifies that we too are a product of Mother Nature's bounty, part of her natural cycles. The silhouette of a tree with spiraling branches refers to the Tree of Life, or a symbol of growth.

Wheat had been one of the chief crops grown in Will County through the mid-nineteenth century, but after 1870 its popularity began to decline because of crop failures, pests, diseases, and lack of cost-effectiveness. Corn soon surpassed it as the area's prime commodity. The soil was better suited to growing corn,

From the Hands of Ceres

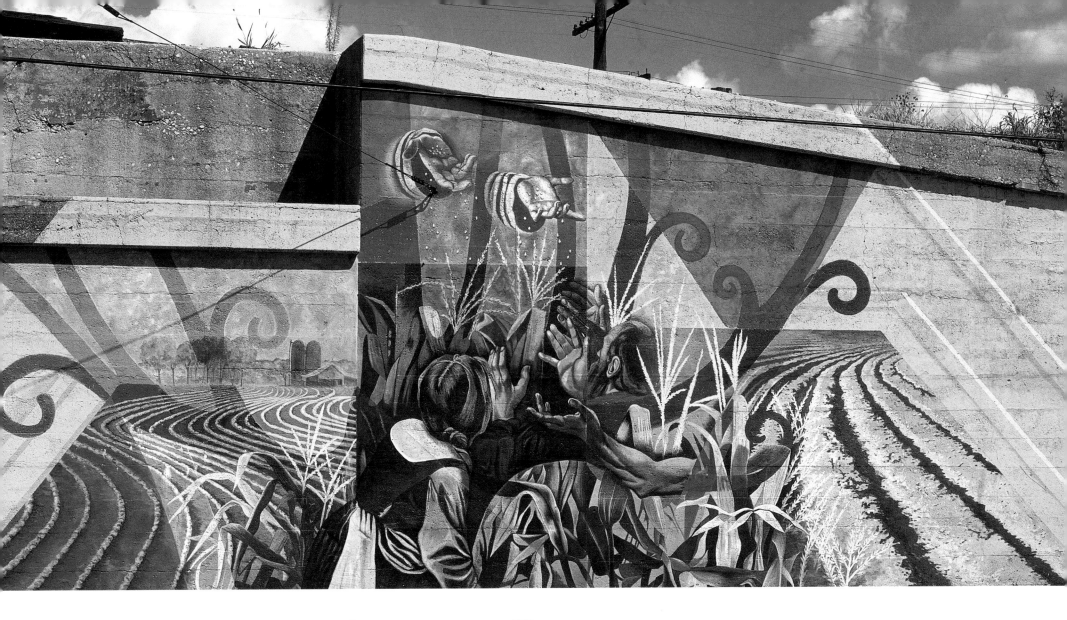

Ode to Will County Farmers

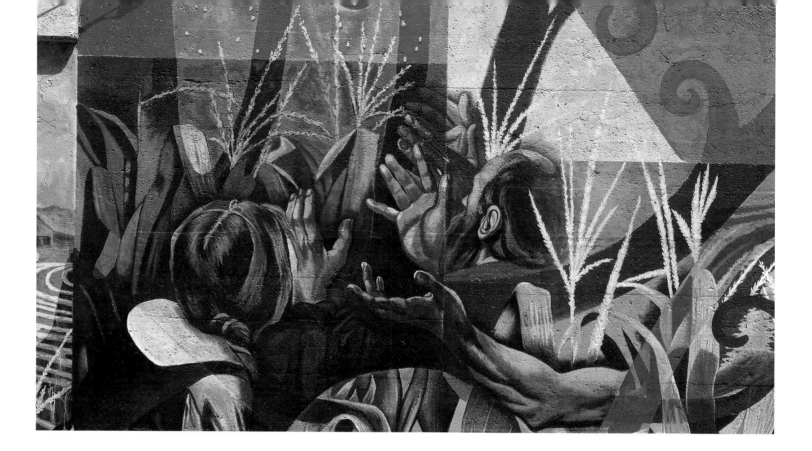

Farmers' hands, receiving
seeds, mix with corn tassels.

and it was easier to harvest than wheat. Also, the expansion of the meat-packing industry in the Midwest favored corn because cattle and hogs preferred it as a feed grain.

Planted and tilled fields, shown on the left and right sides of the mural, suggest that nature's bounty is sown and reaped through hard work and long hours. Also depicted on the left is a farm with grain silos, and a Potawatomi stone plow. Further to the right is an image of the first steel plow.

Although it is commonly believed John Deere invented the steel plow that broke the prairies, the honor rightly belongs to John Lane, a practical farmer and mechanic. A New Yorker, Lane came to Homer Township, near Lockport, in 1833. Like other early settlers of the region, he found the thick prairie soil difficult to turn with the cast-iron and wooden plows that were being used at the time. Soil kept sticking to the surface, and farmers had to make frequent stops to scrape it off.

Experimenting in his blacksmith shop, Lane soon perfected a steel "breaking" plow by adapting a worn-out saw blade that he had obtained from a local saw mill. This new blade had the advantage of scouring itself clean of soil. Although Lane neither patented his invention nor manufactured it on a large scale, local farmers came to his farm (on the northeast corner of present-day Farrell Road and Seventh Street) to buy steel plows. By 1850, Lane's operation employed three men who annually produced about 50 plows from saw blades, until plate steel came on the market. Agriculture was transformed as more acreage was cultivated.

Other blacksmiths borrowed the idea, including John Deere. Deere was the first to mass-produce the steel plow, leading many to believe that he was its originator. When Lane died in 1857, however, *Scientific American* ran an obituary that honored him for revolutionizing agriculture: "The value of this invention to the country cannot be estimated. The name John Lane, Sr. should ever be remembered as one of the great inventors of the country."

After his death, Lane was succeeded in the business by his son John Lane, Jr., who continued to manufacture plows in Lockport for many years. He also patented many improvements in the manufacture of steel.

Dante DiBartolo

Born: Burbank, Illinois 1970

Education/Experience: A.A., Joliet Junior College, 1993; apprenticed with FCPA 1995–1998; trained as a sculptor, Visions Display Shop, Coal City, Illinois 1994–1998.

Current status: FCPA sculptor and mural painter, Joliet, Illinois.

I like the hands-on aspects of the mural work. I enjoy working outside on artwork that people walking by can enjoy.

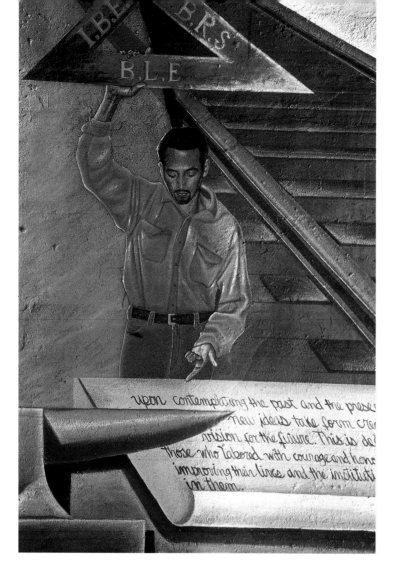

8

The EJ&E Railway and Its
Mexican Workers 1998

West side of the 600 block
of Scott Street

10' H x 26' W
acrylic on concrete

Lead Artist:
Javier Chavira

Assistant Artist:
Dante DiBartolo

This stylized mural presents a broadly symbolic history of the Elgin, Joliet and Eastern Railway, from its origin as an idea and continuing through its incorporation as among the most storied regional railroads in Illinois and Indiana. The painting—which makes dramatic use of perspective and includes both realistic and allegorical figures—also honors immigrant and minority rail workers, mainly Mexican-Americans, who helped lay tracks, work the rail yards, and run and repair the trains.

The figure at the right with the drafting triangle represents the process of creation—the possibility of starting EJ&E Railway, which traces its beginnings to the 1880s. In the triangle are the initials of three unions that represented Mexican-American railroad workers: IBEW (International Brotherhood of Electrical Workers), BLE (Brotherhood of Locomotive Engineers), and BRS (Brotherhood of Railway Switchmen).

The blacksmith figure at the center pays homage to the workers of racial and ethnic origins who labored in the railroad workshop. The final scene portrays men laying tracks, also a tribute to workers of Mexican descent. (One of them is Alex Ledesma, Joliet City Councilman and a former EJ&E employee.)

The note reads: "Upon contemplating the past and the pre-

The EJ&E Railway

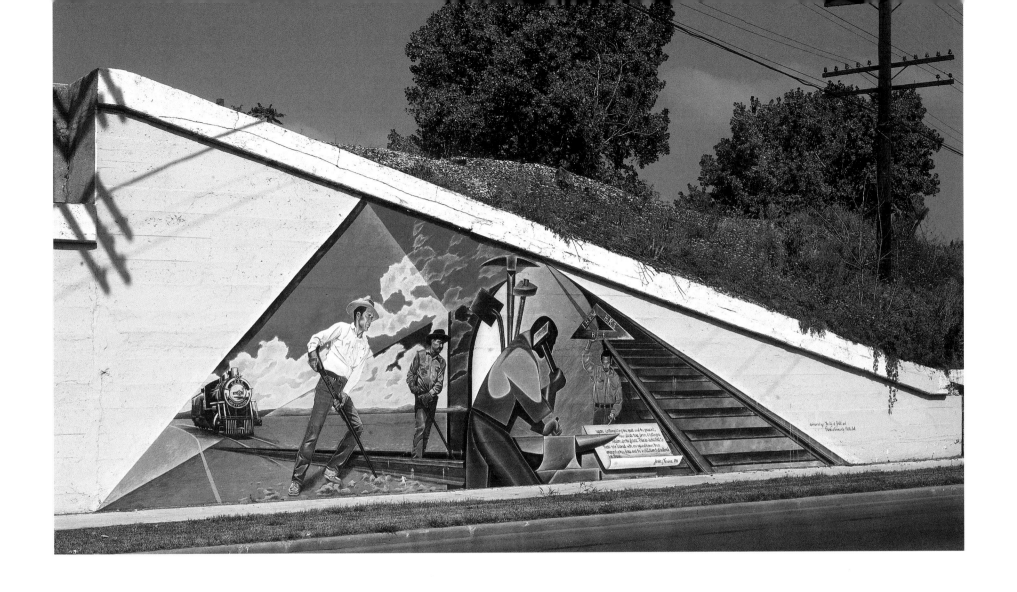

Its Mexican Workers

Immigrant and minority rail
workers laying tracks for the
EJ&E Railway.

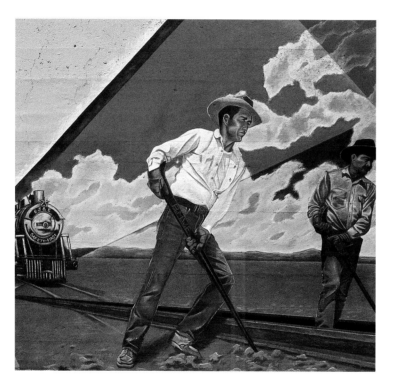

sent new ideas take form, creating a vision for the future. This is dedicated to those who labored with courage and honor, thus improving their lives and the institution that believed in them."

Railroads have played an important role in Joliet's economic, social, and labor history since the 1850s. One of the most significant was the EJ&E, or the "J" as it is widely known. The railroad, which began operations as the Joliet, Aurora and Northern Railway in 1886, provided an outer beltway around Chicago, and had interchanges with other rail lines directly serving the city. From its northern terminus in Waukegan, the railroad extends to Porter, Indiana, with spurs into South Chicago.

By the 1920s, EJ&E was one of the Joliet area's largest employers—few other companies had such a prolonged impact on the local economy. Throughout its history, the railroad had provided jobs to thousands of immigrants and other minority newcomers, many of whom worked in the buildings and switching facilities of the East Joliet Yard. EJ&E reached its peak in the early 1950s, when it employed 5,900 people, owned over 10,000 locomotives and freight cars, and handled nearly one million cars a year. It also pioneered the use of diesel locomo-

tives, steel freight cars, and welded rails.

EJ&E was long allied with the steel industry. In the 1890s, Federal Steel Company executive Elbert "Judge" Gary began buying up steel-related industries, including transportation systems, in a bid to control all phases of steel production. Illinois Steel, along with EJ&E, came under Gary's ownership in 1898. Then in 1901, Federal Steel was absorbed into U.S. Steel, of which EJ&E became a subsidiary. USX, U.S. Steel's successor, sold it to a New York-based firm in 1988.

EJ&E's labor-related triumphs and travails were closely tied to union activity among Joliet's steelworkers. By the early 1890s, many of the area's rail workers had formed five labor unions; but EJ&E workers, like their fellow steel men, were not yet organized. In 1894, however, they formed a local of the American Railway Union (ARU), the organization founded by labor leader Eugene Debs, and workers joined in a national sympathy strike against the Pullman Palace Car Company. The center of action in Joliet was the EJ&E freight yard, where strikers confronted the county sheriff and thirty deputies. The strike failed and ARU members were forced to abandon their union.

National union drives during World War I resulted in the organization of steel and rail yard workers, and by 1919 nearly every worker at EJ&E had joined a union. In August 1919, as part of a nationally coordinated steel strike, 3,000 workers at the EJ&E yards walked off their jobs, demanding union recognition and wage increases. The strikers, primarily unskilled and semiskilled new immigrant workers, wanted "three square meals a day" and even defied a back-to-work order issued by President Woodrow Wilson. But the strike ended in defeat in early 1920.

When Mexicans began arriving in Joliet by the 1920s, many found low-paying, laborious jobs as tracklayers and yardmen for EJ&E, Santa Fe, and other local railroad companies.

9

Gompers' Brotherhood 1998

East-facing wall of Gompers Junior
High School, 1301 Copperfield

7' H x 25' W
acrylic on concrete

Lead Artist:
Jesus Rodriguez

S amuel Gompers, for whom the school was named, was the first great labor leader of the U.S. and a founder of the American Federation of Labor. His portrait is on the far left of the mural. An African sculpture, a Chinese girl, a Native American man, and a Mayan corn goddess are also shown. These "family of man" images represent the cultural diversity of Joliet, as well as of the student body. Paper doll cutouts, symbolizing brotherhood, are superimposed over the portraits. Rays of the sun illuminate the scene.

It is fitting that Gompers (1850–1924) should be commemorated in a mural in Joliet, with its ethnically and racially diverse union work force. He helped lay the foundations of the modern American labor movement. Gompers was born in London, the son of a poor Jewish cigar maker, and had little schooling. His family immigrated to New York City in 1863. Like his father, Gompers worked in a cigar factory, where he encountered bad labor conditions and lived in extreme poverty. He soon joined the Cigar Makers Union, affiliated with the Knights of Labor, and became a naturalized citizen in 1872.

Gompers began his career as labor leader in 1875 when he became president of the Cigar Makers' largest local in New York. Two years later, he led the local through a prolonged and unsuccessful strike that nearly ruined the union. Gompers worked his way up the ranks, rebuilding locals, and in 1881 helped organize a group of national craft unions that took the name American Federation of Labor (AFL) in 1886. Gompers was the AFL's first president, and remained in that position—except for one year, 1895—until his death in 1924.

Gompers' Brotherhood

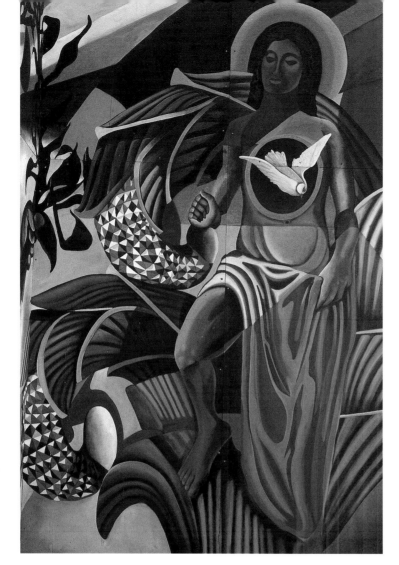

⑩
Visions from a Dream:
An African–American
Neighborhood 1998

North wall of Eliza Kelly Grade School,
100 West McDonough Street

12' H x 28' W
acrylic on sign board

Lead Artist:
Carla Carr

This vibrantly hued mural departs from historical themes to present a series of images resonant with African-American experience, spirituality, myth, and aesthetics. Featuring several interconnected themes and rich in symbolic associations, the painting honors elder women and mothers who impart their knowledge and strength to the community—the ties that bind one's ancestry to the family of humankind. The images are visions of cultural aspirations, the idea of handing down a dream from one generation to another.

On the left, a grandmother figure clutches photographs of her husband and of a son in military uniform. In her other hand is a triangularly folded flag, like those given to the families of fallen soldiers (the young man is a reference to a soldier who had recently been murdered in Joliet). Behind her, a light of wisdom illuminates a vine like family tree. To the elder's right is an abstracted mother-and-child symbol bearing fruit, an image that represents women's role in nourishing family, community, and humankind. It conjures the essence of things hoped for and received.

The central male figure receives the family tree, along with

Visions from a Dream

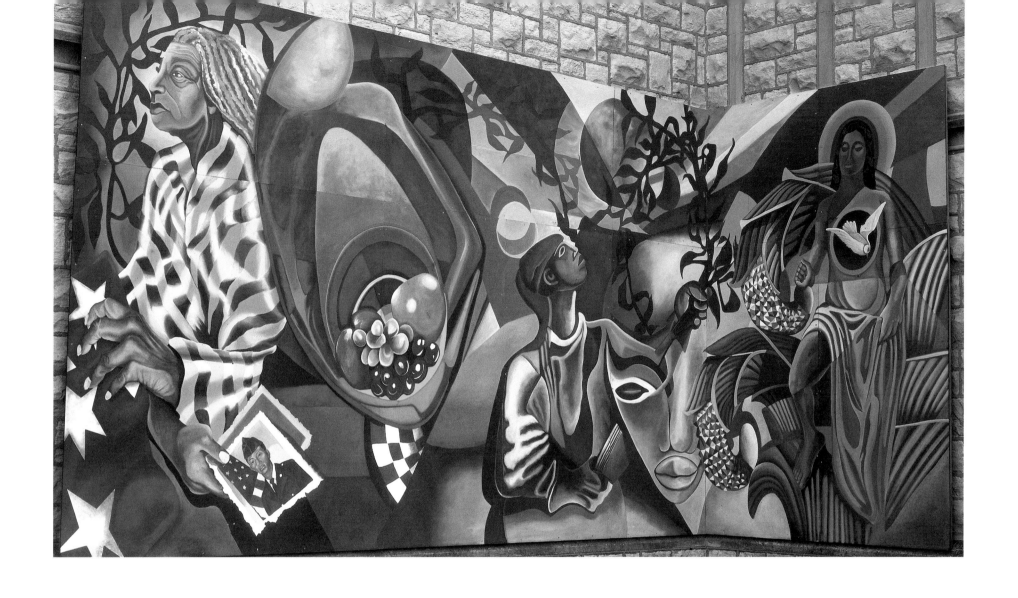

An African-American Community

the wisdom of the older generation. Embodying strength and determination, the young man holds his head high toward the future; he holds a book, symbolizing the importance of education as a means to personal achievement. Connected to him to the right is an African mask, a reference to African-Americans' rich cultural heritage. Above the abstracted face are circular forms that represent the continuous cycles of birth, life, death, and rebirth found in nature and man—as well as in this mural.

On the right, the figure of a nature goddess is shown rising out of a vegetable like form. In contrast to the war references that begin the mural, a white dove of peace emerges from her heart.

The mural is also homage to Kathleen Bolden, who died in 1994. She founded the Warren-Sharpe Community Center, located across the street from where she once lived. Bolden believed that art is an essential part of the quality of life and a source of community empowerment, and she helped bring public art to the neighborhood. *Visions From a Dream* is a continuation of Bolden's dream to have people from the community envision its culture through art.

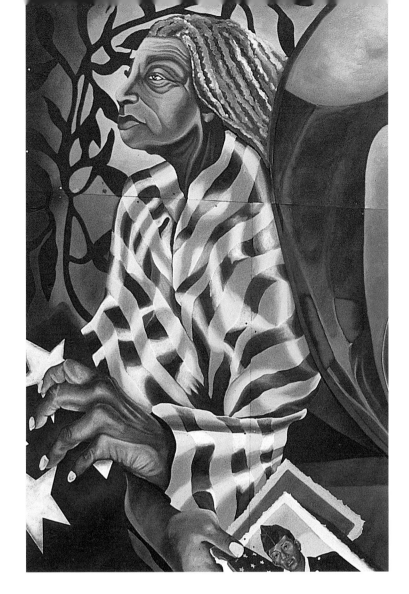

Carla Carr

Born: Joliet, Illinois 1971

Education/Experience: M.A., painting, Governors State University, 1999; B.A., art and psychology, Creighton University, 1993; created community-based murals since 1995.

Current status: studio painter, enrolled in M.F.A. painting program, Northern Illinois University; Joliet, Illinois.

Being a part of an organization which believes as I that art brings meaning and enjoyment to life has been both rewarding and challenging.

This series of three murals, designed by Kathleen Scarboro and Kathleen Farrell, commemorates the Joliet region's symbiotic relationship to the Illinois & Michigan Canal. The murals, based on historic photographs, are located at the northwest corner of Bluff Street and West Jefferson Street, at the entrance to Billie Limacher Bicentennial Park.

Completed in 1848, the Illinois & Michigan Canal helped transform Joliet from a frontier outpost into a commercial center. The 96-mile-long waterway connected the Great Lakes to the Illinois and Mississippi Rivers—ultimately, the Atlantic Ocean to the Gulf of Mexico—opening up the floodgates to development in the region and creating a vital area of commerce from Chicago west to LaSalle-Peru.

Constructed mainly by Irish, German, and Scandinavian immigrants, the canal changed not only the landscape of northern Illinois; it had an immediate and lasting impact on the Midwestern economy. By opening up a waterway through the Heartland, the canal brought an influx of new people, products, prosperity—and ideas—to the towns and communities that had sprouted along its corridor, contributing greatly to Joliet's (and Chicago's) growth as a hub of transportation and industry.

Prior to the start of the canal's construction in 1836, Native Americans, explorers, fur traders, and early pioneers had all used water routes between Lake Michigan and the Illinois River Valley. In fact, it was French-Canadian voyageur Louis Joliet, the city's namesake, who in 1673 first suggested that a waterway be built connecting the Great Lakes and the waters that flowed to the Mississippi River. If "half a league of prairie" could be cut through the Chicago portage site, he wrote, one could travel from Lake Michigan to the Gulf of Mexico entirely by boat.

Joliet's vision became a reality 175 years later. By the mid-1850s, however, railroad developers had laid tracks along the

A Corridor in Time

canal route, and as the rail transport of freight became increasingly competitive, the canal reduced tolls. After the 1893 economic depression, commercial traffic and income declined dramatically, though the canal continued to be a major carrier of cargo until after World War I. The opening of the Illinois Waterway in 1933 ended the shipping history of the canal. The U.S. Congress recognized the historic and cultural significance of the Illinois & Michigan Canal region in 1984 by designating it the country's first National Heritage Corridor, preserving it as a link between the past and the world of today.

These murals, painted directly on stone and rendered in tones that evoke tranquil recollection, also preserve the past of the Illinois & Michigan Canal for today's viewers and future generations. They are aptly titled; the canal was not just a passageway through space—a landscape—but also a corridor leading back through time to the beginnings of Joliet's recorded history. The murals seem to materialize right out of the limestone bluffs, just as the "City of Stone" was literally built up from the vast deposits of dolomite—or "Joliet limestone"—prevalent in the area. The canal's walls were also built of limestone, helping to give rise to Joliet's quarry industry in the last half of the nineteenth century.

The Illinois and Michigan Canal

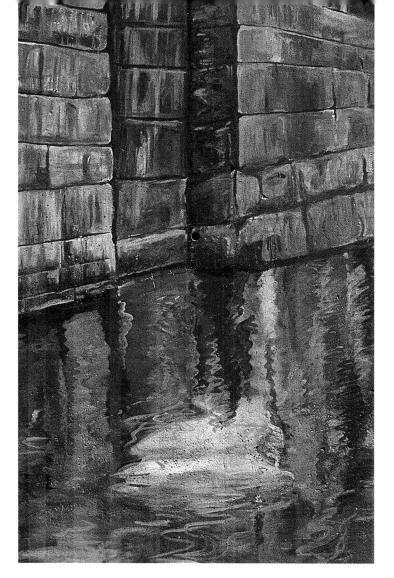

⑪

The Illinois & Michigan Canal
at Channahon Lock 1997

North side of West Jefferson Street
at Bluff Street

17' H x 14' W
acrylic on concrete

Lead Artists:
Kathleen Scarboro
and Kathleen Farrell

Assistant Artists:
Dante DiBartolo, Eric Standish,
David Wilson, Carla Carr,
Greg Binder and Jesus Rodriguez

There were originally fifteen locks built on the canal, plus two others north of Lockport. Locks were needed to lift or lower boats along the course of the canal as water levels changed; there was a 141-foot change in elevation between the Illinois and Chicago Rivers. The wooden canal locks were all hand-operated by lock tenders who opened and closed the gates—similar to huge swinging double doors—as boats entered and left the lock chambers. Water filled the lock to lift the boat, or was drained to lower it.

Lock tenders lived in small, canal-owned houses adjacent to each lock. They were on call twenty-four hours a day, made $300 a year, and at times had to break up fights among ship captains jockeying for position. Only two lock tenders' houses survive: one at the Aux Sable Aqueduct near Morris, and the other at Lock #8, just south of Channahon (some miles downstream from Joliet), which is pictured in this mural. "Channahon" is an Indian word signifying "meeting of the waters."

Channahon Lock

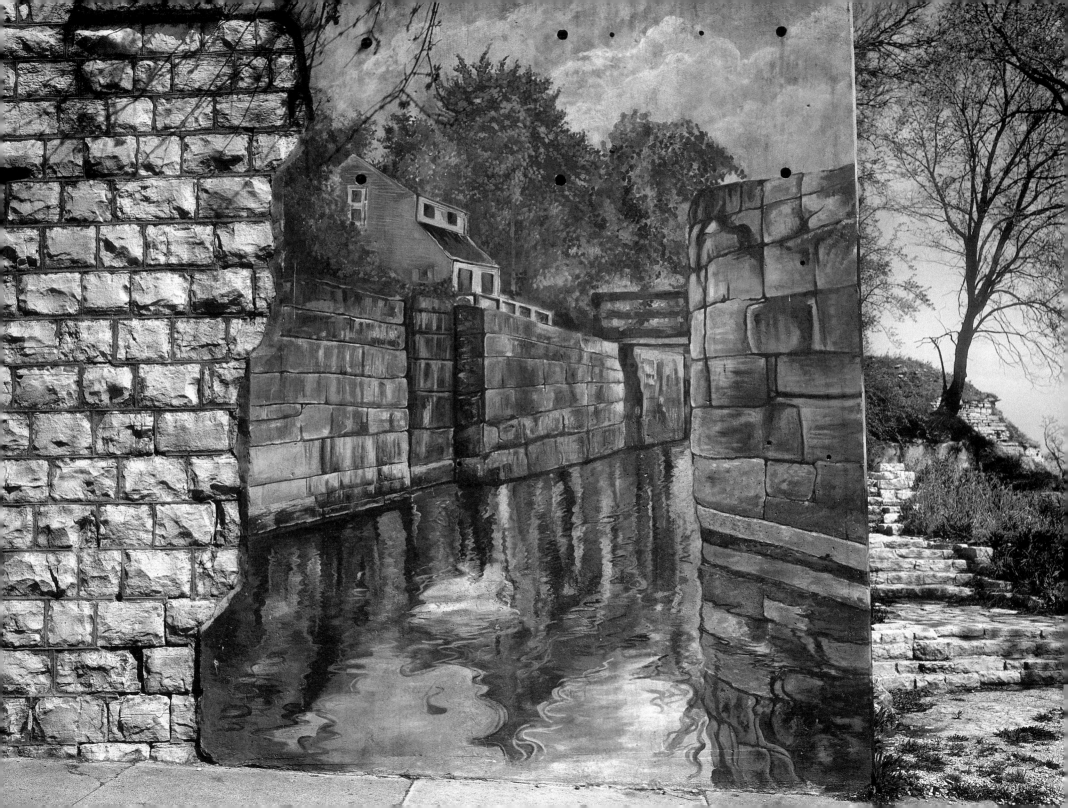

The canal ran through Joliet on the west side of the Des Plaines River. Both waterways are pictured in this mural, which presents a scene of the city in the early 1900s, looking south down the river toward the old Jefferson Street stone bridge.

Attributed to a French word denoting "flat terrain," the Des Plaines has for centuries played a vital role in the areas now known as Joliet and Will County. Semisedentary Potawatomi Indians, the last and most prevalent Native American group in the region, camped in villages alongside the river's banks and fished its waters from birch bark canoes. In the fall of 1673, near the end of their expedition to the Mississippi River (in hopes of finding the fabled Northwest Passage to the Orient), Louis Joliet and Father Jacques Marquette traversed the Des Plaines as well. Pioneer settlers built cabins and mills on the river, which pro-vided them with fish and waterfowl to eat. The Des Plaines, along with the canal, spurred Joliet's industrial growth, helping to launch its eras of stone and steel, creating thousands of new jobs for immigrants.

In this mural, the Bush Building, which stood on a small island between the river and the canal on the southwest corner of Bluff and Exchange (Jefferson) Streets, dominates the skyline just beyond the bridge. The stone block was built by the Bush brothers—including Frank Bush, namesake for Bush (now West) Park—and at the turn of the century housed a printing plant, a planing mill, and a clock manufacturing company. The building was destroyed by fire in 1898, about the same time the old bridge was demolished; the current lift bridge replaced it in 1932 as the Illinois & Michigan Canal's successor, the Illinois Waterway, neared completion.

The remains of Joliet's Lock #5 are near the upper right side, near a grove of trees. The lift lock was 110 feet long and 18 feet wide, with a lift capacity of 10 feet. The stone buildings of historic Bluff Street—Joliet's first business district, dating to the 1830s—line the water's edge.

The Des Plaines River

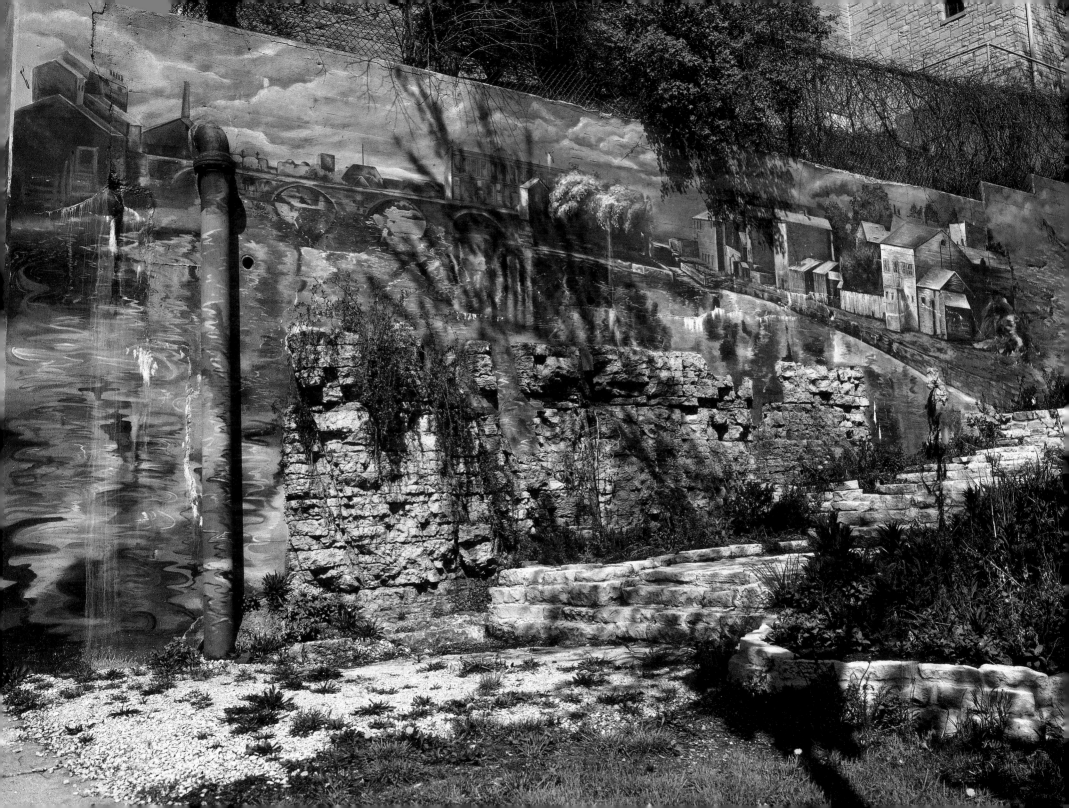

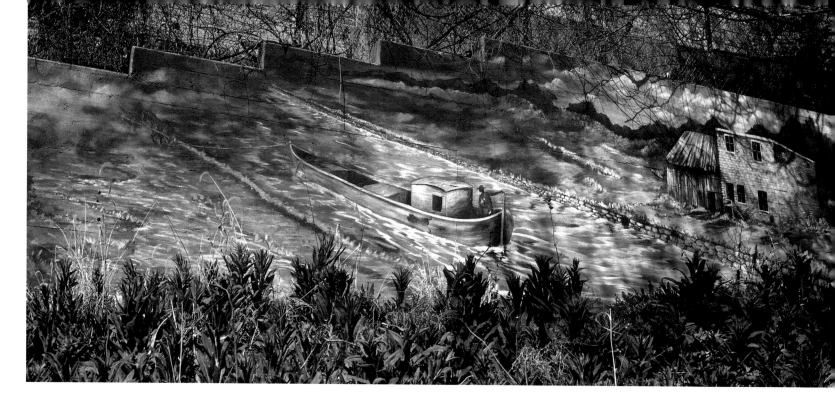

13

The Illinois & Michigan Canal:
Cargo Boat 1998

North of the Des Plaines River mural
on the west side of Bluff Street

15' H x 38' W
acrylic on concrete

Lead Artist:
Greg Binder

This mural depicts a typical canal town scene circa 1850s. Besides bridges, dams, aqueducts, and lock tenders' houses, towpaths for mules to pull the motorless cargo boats were also constructed along the canal. The boats were long and narrow—most were 100 feet long—in order to fit into the locks. They could carry 150 tons of goods.

Also pictured here are some of Bluff Street's early stone buildings, including the twin houses that were unique to Joliet. These adjoining structures were often built by fathers and sons, though friends also shared construction costs and work. Owners had their businesses on the ground floor and lived on the top floor. The houses were usually long and narrow, since lots were only 25 feet wide.

Cargo Boat

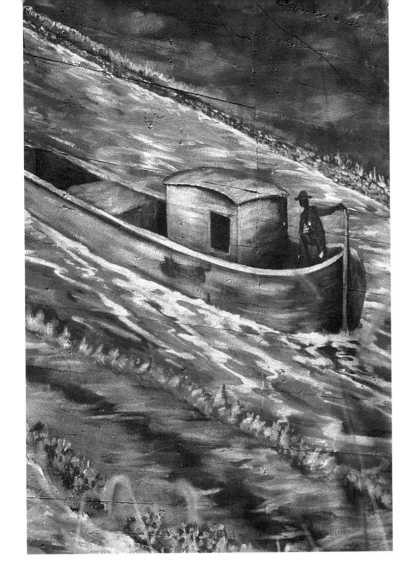

Greg Binder

Born: Duluth, Minnesota 1967

Education/Experience: M.F.A, painting, New Mexico State University, 1997; B.F.A., painting, Southern Illinois University, 1992.

Current status: studio painter; adjunct instructor of drawing, Waubonsee Community College, Sugar Grove, Illinois.

My paintings are like a stage play without a script. I set the stage and hire the actors, then see what happens.

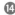

Joliet Limestone:
Our Canals and Quarries 1997

East retaining wall of the Des Plaines
River at Washington Street

10' H x 60' W
acrylic on concrete

Lead Artists:
Kathleen Farrell
and Kathleen Scarboro

Assistant Artists:
Dante DiBartolo, Carla Carr,
David Wilson, Eric Standish,
Jeanne Zimmerman, Erin Jordan
and Javier Chavira

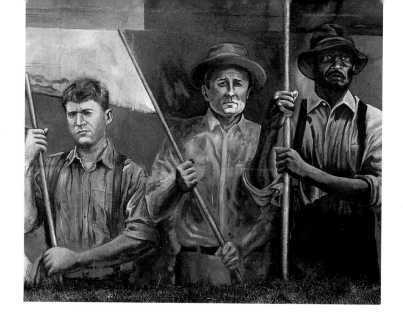

Exceptional in its historical detail and social conscience, this mural honors the canal and quarry workers who literally helped build the City of Stone throughout the nineteenth century. Depicting the lives, struggles, and families of the men who moved earth, water, and limestone, often at great toil and peril, the artwork features workers (mainly Irish) digging the Illinois & Michigan Canal, deepening the Des Plaines River, and extracting stone from quarries. There are few richer public monuments to Joliet's storied labor heritage.

Begun in 1836 and completed in 1848, the Illinois & Michigan Canal connected Lake Michigan to the Illinois River—ultimately the Atlantic Ocean to the Gulf of Mexico. It was at the time the largest construction project in the state's history, and its opening— along with the railroads that soon followed— brought commercial prosperity to Joliet and other towns along the waterway's 96-mile route.

Facing labor shortages, canal contractors placed ads in eastern newspapers. Irish immigrants—who had gained a reputation as hard workers on public works projects out east—flocked to Illinois to dig the canal by hand. German, Scandinavian, and other ethnic groups were also attracted by the promise of jobs. But as the saying went, "It takes four things to build a canal—a pick, a shovel, a wheelbarrow, and an Irishman."

By August 1838, 3,200 men were toiling on the canal. It was difficult and dangerous work. In addition to the arduous task of digging through prairie sod and stone, workers faced such hazards as heat, flood, snakes, and malaria-causing mosquitoes. Many died of diseases such as dysentery and "canal cholera" (perhaps not true cholera), a grim fact that is dramatized by the presence of gravestones in the mural. Unsanitary living conditions aggravated health problems—diggers lived in crude shanties, with up to twenty-four men in one structure.

Joliet Limestone

Local lore has it that canal workers were paid a dollar and a gill of whiskey per fifteen-hour workday, plus board, and many settlers considered them a dirty and drunken lot. Yet diggers did protest the harsh nature of their work. In 1847 in nearby Summit, for example, a group of workers went on strike for two weeks, demanding a thirteen-hour day with an hour off for both breakfast and dinner. But the effort failed.

Joliet workers were leaders in the Eight-hour Day Movement of the 1880s. Their slogan, "Eight hours labor, eight hours recreation, eight hours rest," is included in the mural. May 1, 1886, is the date of the first Labor Day parade, a procession of 80,000 striking workers in downtown Chicago. (Three days later at a protest meeting in the city's Haymarket Square, four workers and seven policemen were killed as the result of a thrown bomb and police gunfire. Four Chicago labor activists and anarchists were unjustly hanged for the crime.) Joliet workers celebrated May Day for the first time in 1889, though five years later the holiday was moved to September.

The mural also honors the blacks who migrated to the area in large numbers in the 1890s to dredge the Des Plaines River and

Irish gravestones, a call for the 8-hour day, the Sanitary & Ship Canal under construction, and dynamite used in blasting the limestone riverbed are depicted in the mural.

Our Canals and Quarries

to build the Sanitary and Ship Canal.

The foundation of Joliet industry was literally built of stone. The region rests upon vast deposits of dolomite, which became known as "Joliet limestone." In the latter half of the nineteenth century, stone became a major building block not only in the Joliet area but also throughout the Midwest. Settler Martin Demmond first extracted limestone from nearby bluffs in 1835. Quarrying got a boost with the building of the Illinois & Michigan Canal's locks, bridges, and aqueducts, and by the mid-1850s nine quarries operated in the Joliet area. The industry also benefited from the cheap transportation of stone provided by the canal. Quarrying grew dramatically in the 1870s, partly as a result of the rebuilding of Chicago after the 1871 fire (the Chicago Water Tower and Pumping Station, built of Joliet limestone, gained fame for withstanding the flames).

By the mid-1880s, quarrying was Joliet's most prominent and prosperous industry, employing about 1,500 stonecutters and quarrymen; largely unskilled, they worked nine months a year and averaged $40–50 a month in wages. Employment peaked at 2,300 in 1890 when as many as 3,000 rail cars of stone were shipped a month. Local quarry owners included William Davidson, Charles Werner, Lorenzo Sanger, and W. A. Steel, a mayor of Joliet in the early 1870s.

Joliet stone was used locally to construct houses, bridges, churches, hospitals, businesses, gravestones, and government buildings, including schools, libraires, post offices, jails, over forty courthouses, as well as the capitals of Illinois and Michigan. It was also cut into flagstone and made into crushed stone.

Quarrying, hard and heavy work, was done by some of the area's first immigrants— Swedes, Poles, Germans, Italians, and African-Americans. Pictured in the mural are four stone workers, each grasping long metal pry bars used to work the seams of rock, up to two feet below the surface and in beds 50 to 100 feet thick. (Area civic leaders and townsfolk posed for the portraits, including John Lamb, a historian with the Illinois & Michigan Canal Commission, and Gerald Adelmann of the Canal Corridor Association.)

Quarrymen were among the most militant workers in northern Illinois in the late nineteenth century. Suffering from low pay and frequent unemployment, some men joined the Knights of Labor, then the largest labor organization in the country; the local assembly was led by Michael Haley. Between 1882 and 1893, more than 1,000 Will County stone workers struck six times to improve their conditions, twice leading to bloody clashes with authorities.

FCPA artist Erin Jordan refines the image of an 1845 Irish gravestone.

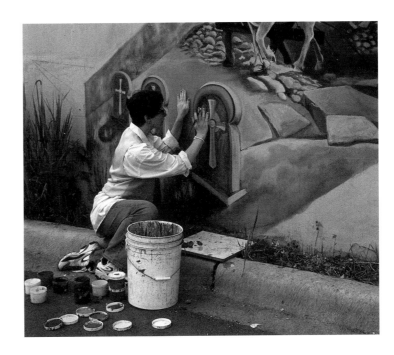

In May 1885, hundreds of quarrymen in Joliet, Lockport, and Lemont went on strike to protest a wage cut (from $1.75 to $1.50 for 10–12 hour days) and owners' threats to use strikebreakers; the workers involved were mostly Swedish, Polish, and German. The state militia was called. In Lemont, two workers were killed as the result of a "slight skirmish," and twenty-seven were wounded (ten residents, including women, and seventeen troops). Strikers were also arrested and wounded in Joliet. The strike ended in defeat—its leaders were blacklisted and strikebreakers were brought in. Although an 1893 strike did lead to a wage increase, it also led to fatal violence by troops.

Production of cut building stone declined after 1890 due to a number of factors—competition from Indiana quarries, a financial depression, the increasing popularity of concrete as a building material, and changing architectural styles. By 1906, the area's eight stone quarries, three gravel companies, and two stone-crushing enterprises employed 532 people. By the 1920s, quarries had shifted their production to crushed stone, used primarily in road construction and concrete.

The City of Stone may be faint memory to most Joliet residents. Yet it still lives on in many of the city's buildings—and in this vivid mural, which is painted on locally made concrete and sited by the river that drew many workers here in the first place.

 15

Selling Sentiment:
Gerlach–Barklow 1997

Northeast corner of East
Washington Street at
Richards Street

10' H x 36' W
acrylic on sign board

Lead Artists:
Kathleen Scarboro
and Kathleen Farrell

Assistant Artist:
Dante DiBartolo

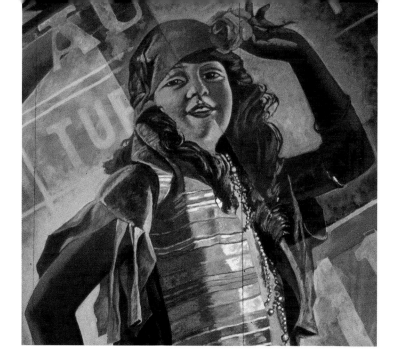

This visually evocative mural is a tribute to the thousands of Joliet residents, including many local painters and illustrators, who worked at the Gerlach-Barklow Company (later Rust Craft Greeting Cards, Inc.) from 1907 to 1971. The plant—which once covered an entire city block across the street from where the mural is located—was primarily known for its production of wall-hanging advertising art calendars, and was at one time the largest facility of its kind in the world. The painting takes its title from the company slogan: "Selling Sentiment— The Friendliest Business in the World."

The firm was founded in 1907 by Theodore Gerlach, a Joliet native, and Edwin Barklow, both of whom had been salesmen for an Iowa calendar company. After the original plant was built on East Washington Street between Richards and Union Streets, the businessmen secured rights to copy several popular classic paintings for calendar subjects, while also hiring local artists to create original images for reproduction. Their first line of calendars was of such high quality that the company's reputation was soundly established.

Gerlach-Barklow's calendars were purchased by the millions by firms and businesses throughout the country and then mostly given away as goodwill advertising gifts for customers. Subjects included beautiful women, cute children, mothers with infants, historical and landscape scenes, sports, animals, food, and flowers. The company also manufactured and printed greeting cards, postcards, ink blotters, booklets, wrapping paper, fans, and other novelty advertising items.

By 1924, Gerlach-Barklow became affiliated with three other firms under a parent company, United Printers and Publishers, Inc. The companies shared space and equipment at the East

Selling Sentiment Gerlach-Barklow

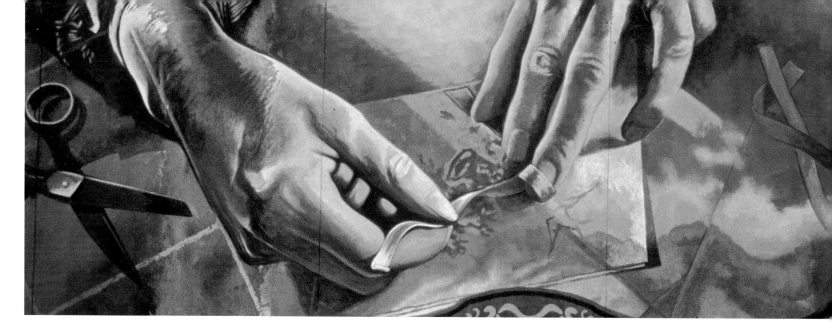

A woman's hands tie a bow on an elaborate greeting card.

Washington Street plant. One of the firms was the P. F. Volland Co., which had produced greeting cards and children's books earlier in the century.

Volland printed the original Raggedy Ann and Andy books, which (from 1918) were written and illustrated by Johnny Gruelle, an Arcola, Illinois, native. The original cloth dolls were created by Volland to promote the books, and became enormously popular; they can now be worth $1,000, with the original label attached. Gruelle eventually wrote forty books which were translated into 150 languages. The company was also the first to publish *The Wonderful Wizard of Oz* (1900) by Chicago native L. Frank Baum, with illustrations by W. W. Denslow. Volland ceased operations in 1934.

Among Gerlach-Barklow's most popular and talented early artists were two women, Zula Kenyon (1873–1947) and Adelaide Hiebel (1886–1950s), each of whom created high quality paintings for the company for about 35 years. Although both trained at the Art Institute of Chicago, they were not considered "real artists" in their lifetime because of the commercial nature of their work and because women were not encouraged to pursue fine art careers. Today, though, calendar prints painted and signed by Kenyon and Hiebel are sought-after items by calendar art collectors in Joliet and throughout the country. Their original paintings are valued at up to several thousand dollars.

Kenyon's themes included Victorian-era women in romantic settings, animals, landscapes, and a popular "bluebird series." Hiebel replaced Kenyon in 1919. Her subjects were similar, including beautiful women, and children and animals in cute situations. Hiebel, who often used local people as subjects, was known for her 1928 portrait of Lois Delander, the Joliet high

school girl who a year earlier was crowned Miss America.

Gerlach-Barklow and its affiliates were union plants, and at one time were among Joliet's largest employers—more than 1,000 people worked in the factory by the 1950s, along with 500 full-time salesmen covering all forty-eight states and many parts of the world. The Gerlach-Barklow division was bought out in 1959, and Rust Craft Greeting Cards, Inc., acquired the plant several years later. Local manufacturing was phased out in 1971, and the old red brick factory was mostly destroyed by fire in 1992. Five years later, the land was used for Richards Grove, a low-income housing development.

The mural's complex design suggests a discovered cache of valued memorabilia, with various images piled one upon the other. In fact, the artists were given access to the large collection of Gerlach-Barklow materials amassed by Ted and Erma Chuk, Joliet antique dealers. The artwork's color scheme—greens, burgundy, and cream—reflects one of the company's favorite calendar series, which featured a gypsy lady and parrot. That painting is pictured here, along with images of the plant's facade, fancy calendar frames, and numerical dates. On the right, a pair of hands honors the many Joliet women who worked in their homes to finish decorating the greeting cards with bowknots—at the rate of hundreds of ties an hour!

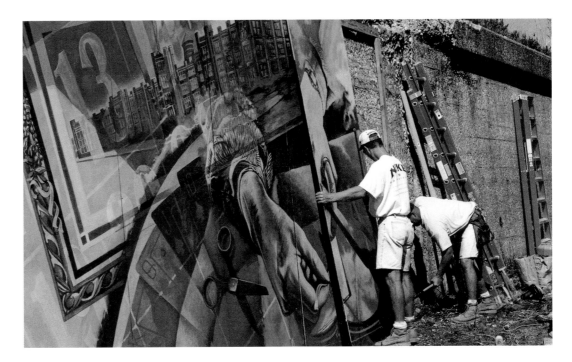

 16

Joliet: City of Steel 1997

Northeast side of Michigan Street
at East Washington Street

10' H x 35' W
acrylic on sign board

Lead Artist:
Javier Chavira

Assistant Artists:
Dante DiBartolo, Greg Binder
and Carla Carr

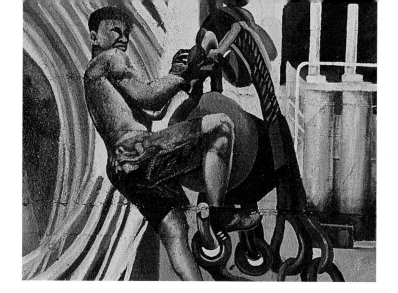

This stylized mural honors Joliet's steel industry, as well as its workers, both men and women. Along with images of the Joliet Works steel mill and the Des Plaines River, which helped give rise to the industry, the artwork features several of the iron and steel products made in the city—girders, wire, fence, and machine parts.

Joliet's era of steel—its transition from a "country town to a modern, manufacturing city," said a local newspaper—was launched in 1869 when the Union Coal, Iron and Transportation Company built a rolling mill on North Collins Street. A year later, the plant produced its first iron rail for the westward-expanding railroads. The region's abundance of coal (for power), water (for steam), immigrant labor, as well as the city's favorable location, combined to make Joliet a nationally prominent manufacturer of iron and steel.

The company was reorganized into the Joliet Iron and Steel Company in 1873, and added two new Bessemer converters, among the earliest in the U.S. The Bessemer process produced purer and stronger steel. It was also faster than the old method, enabling the Joliet plant to manufacture larger numbers of more durable steel rails.

The presence of steel mills and their workers drew many steel-related industries to the area. Among them were several wire firms, including the American Steel and Wire Company, which was affiliated with Joliet Steel and had plants on Scott Street and in nearby Rockdale. The company prospered due to the growing demand of barbed wire in the West. Other factories manufactured stoves, locomotive engines, machinery, and horseshoes.

In the late nineteenth century, Joliet Steel was the site of many technological innovations that led to the increased production of iron and steel. It had also begun to diversify its products. By the late 1880s, Joliet Steel was the world's largest producer of steel

Joliet City of Steel

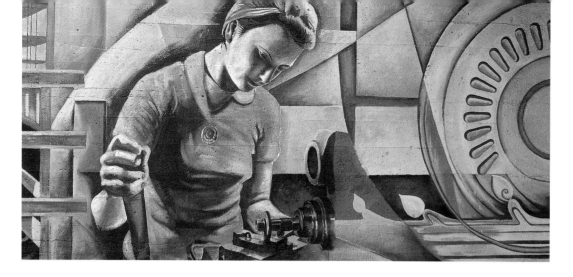

A woman operates a
1940 milling machine.

rails, and the nation's leading manufacturer of wire rods. In 1889, the mill, along with American Steel and Wire, became part of the Illinois Steel Company; it employed 2,000 men, many of whom were from the British Isles. Several years later, steel rails were discontinued in favor of other products. In 1898, Illinois Steel came under the control of the Federal Steel Company, headed by Elbert Gary. J. P. Morgan acquired Andrew Carnegie's steel holdings in 1901 and combined them with Federal Steel to form United States Steel, America's first billion-dollar corporation.

Joliet's steel production peaked with military contracts during World War I, but it declined during the Great Depression. The local plant quit manufacturing iron and steel in 1932, and much of the works was dismantled. The site was revived in 1935, however, and for the next several decades rod and wire mills produced nails, barbed wire, fencing, mesh, and many other steel products. In 1963, the company became known as the Joliet Works of U.S. Steel. It was unable to compete with overseas manufacturers, however, and the closing of a wire mill in 1979 marked the end of the Joliet Works. It is now maintained as the Joliet Iron Works Historic Site. USX (formerly U.S. Steel) and a revamped American Steel and Wire still make products in the area, but on a much-limited scale.

The city's union movement was born in the steel mills in the 1870s. Its first local, the Amalgamated Association of Iron and Steelworkers (a forerunner of the United Steelworkers), was formed during a successful strike against a wage cut. Although skilled workers found it easy to organize craft unions and command good wages—Joliet boasted six such locals by 1883—unskilled laborers were not organized into a local assembly of the Knights of Labor until 1881.

As the steel industry grew, becoming more mechanized and productive, fewer skilled workers were needed. Wages were lowered and work hours increased—most steel men toiled twelve hours a day, six days a week. The 1890s depression hit the industry hard; the steel works were only open for six weeks in 1893, and then shut down for long periods over the next three years. During the early years of the twentieth century, when thousands of immigrants arrived from Eastern Europe to find work in Joliet steel and wire mills, the labor force changed significantly. The union movement, however, did not keep pace

with industrial growth, as U.S. Steel refused to sign union contracts.

Industrial unionism strengthened during World War, I due to labor shortages and sympathetic government policies. John Fitzpatrick, head of the Chicago Federation of Labor, and labor leader William Z. Foster led a campaign to organize steelworkers, including immigrants and blacks, particularly in the Chicago area. By the summer of 1919, Joliet mills were fully organized. But when "Judge" Gary, chairman of U.S. Steel, refused to meet with union leaders—who demanded an eight-hour day, better working conditions, and union contracts—Joliet steel men joined 365,000 workers in a nationwide strike that began in September 1919 and shut down the industry for three months.

Joliet strikers showed more unity and determination during the walkout than most other groups of steelworkers. Besides management, they faced many opponents—city businessmen, local government, company guards, and antilabor newspapers. The Will County Central Trades and Labor Council supported the strike, and the organization staged several rallies. Foster and labor activist Mary "Mother" Jones attempted to address Joliet strikers—though the sheriff prevented Jones from speaking.

In January 1920, national union leadership called off the

Great Steel Strike due to a court injunction and the presence of federal troops, and workers returned to the mills without a contract. While the union movement in Joliet had suffered a major defeat, a solid core of trade unionism still existed in the city and the movement was not entirely broken—not until the 1930s would industrial workers again organize on such a mass scale. The struggles of steelworkers during the strike helped establish unionism on a permanent basis in Will County, making it an essential feature of civic culture.

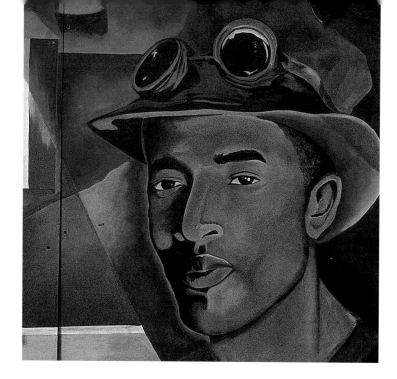

 Joliet's History, Our History:
African-Americans 1996–1997

Northeast corner of East Washington
Street at Eastern Avenue

10' H x 16' W
acrylic on sign board

Lead Artist:
Carla Carr

This African-American history mural mingles past and present in a vibrant montage of designs and images. Long an integral part of Joliet and Will County's industrial and labor history, blacks—as this mural demonstrates—have also contributed greatly to the region's religious, artistic, political, and educational heritage.

African-Americans have played a role in Joliet's history since early settlement. In fact, while Charles Reed is generally regarded as the founder of the present-day city in 1832 (he and his family were the first white settlers within the town's original limits) there was already a black man living nearby in a shelter. Neither his name nor the exact site of his home has been preserved, but it is possible he was the first resident within the boundaries of what was to become Joliet. Early historians write of "Black Bob" and "Dick," both of whom lived in the county as early as the 1820s and traded with Indians and settlers.

Although the number of blacks in the area remained low until the late nineteenth century when many helped dig the Sanitary and Ship Canal, their fate was intertwined with national events. By the 1840s, Illinois had become a battleground over the issue of slavery—opposition to it was deeply entrenched in some parts of the state. Fugitive Slave Laws (which allowed fleeing slaves to be arrested and sent back to slavery) made permanent settlement in the state a perilous adventure, although many blacks did pass through Will County on their journey to freedom.

Set against a backdrop of colorful textile patterns, the mural's central figure is Frederick Douglass. The former slave and famed orator-abolitionist signifies the region's ties to the Underground Railroad. This system of secret routes, safe houses, and support

Joliet History, Our History

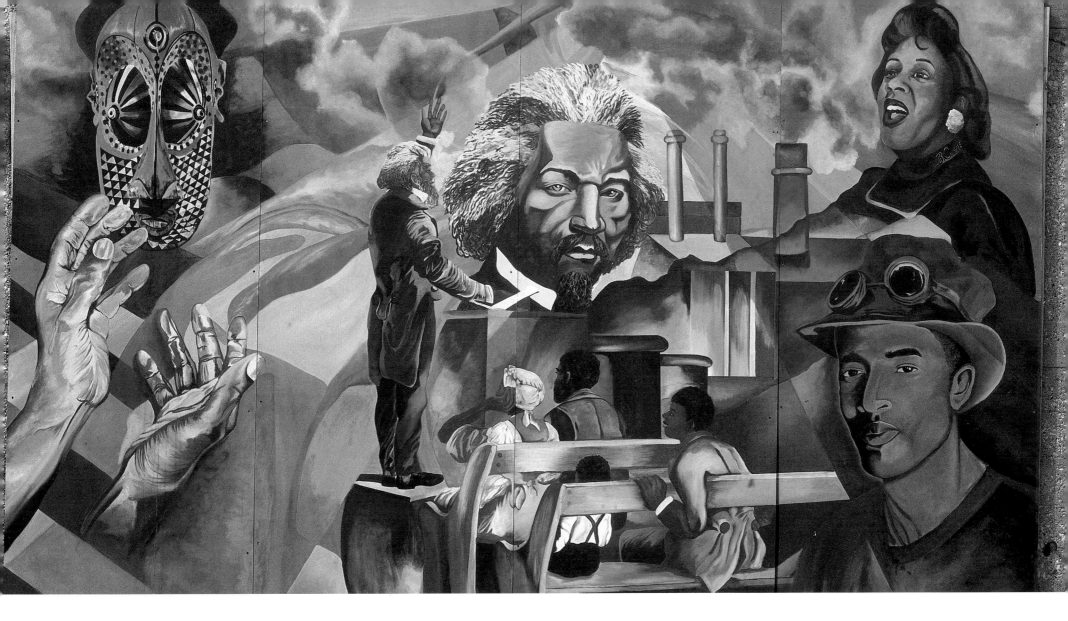

African-Americans

77

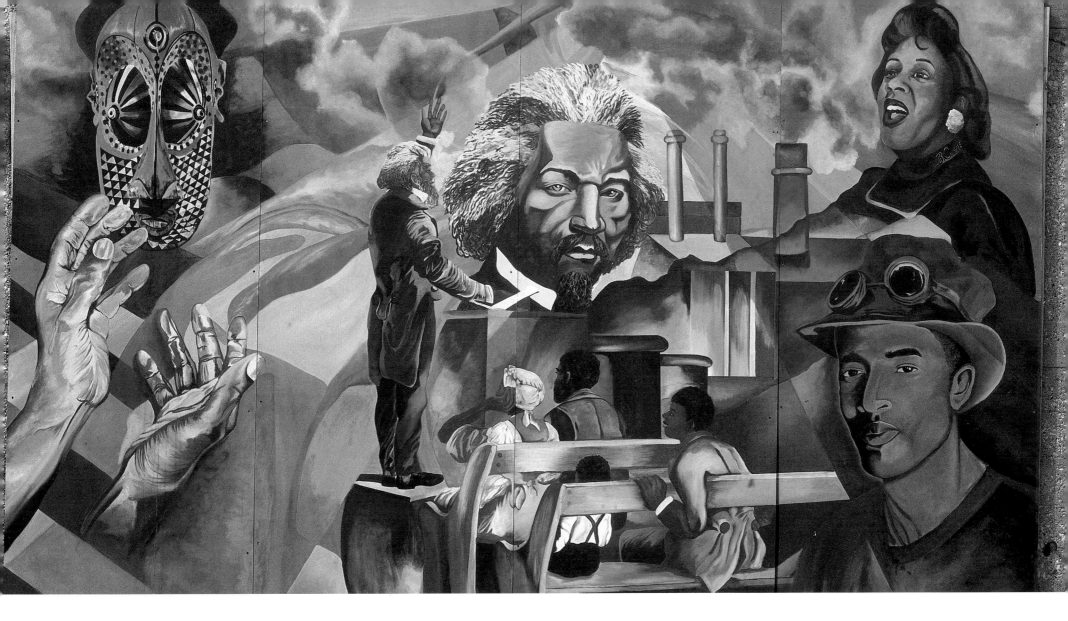

African-Americans

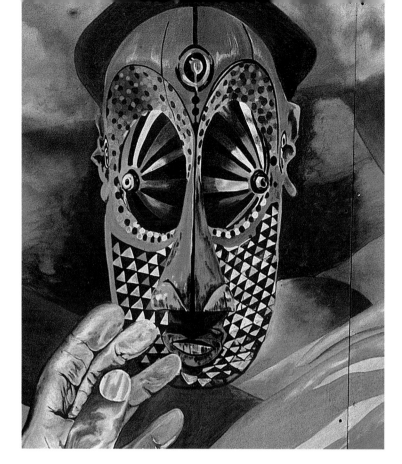

The recollection of African art inspires African Americans.

The case of Henry Belt brought the issue of slavery to an emotional climax. Belt was a Pennsylvania-born free man who was a barber at Joliet's Exchange Hotel. Falsely arrested by bounty hunters in 1847 as a fugitive slave and brought before a biased judge, Belt bolted to freedom when a group of area abolitionists staged a courthouse disturbance to distract authorities. While law officials searched the town for the next several days, Belt was sheltered about two blocks north in the cellar of a shop owned by a man named Baker. When it was safe, Belt fled again, his ultimate fate unknown.

With emancipation, blacks organized their own churches. Several images in the mural portray religious activities. On the upper left, hands reaching toward an African mask symbolize the search for ancestral spiritual traditions; in the lower center, a family worships at Brown Chapel A.M.E, the first black church in Joliet—established in the 1880s by Thaddeus Fleming, a Virginia-born minister who in 1878 founded the first Baptist church in Will County, in Braidwood; and, on the upper right, a church singer modeled after renowned local vocalist Juliet King illustrates how African-Americans have used gospel as a springboard to musical success.

Rounding out the picture, images of a black miner and a steel mill represent African-Americans' contributions to the Joliet

for escaped slaves operated for about a half-century, from the end of the War of 1812 to the end of the Civil War. Douglass visited Joliet in 1859 at the behest of the Will County Anti-Slavery Society, which had been organized in a Merchant's Row building in the late 1830s. He spoke at Young's Hall on Chicago and Van Buren Streets, and stayed at the home of the Hill Family on Scott Street.

area's labor heritage. Hundreds of blacks began arriving in Braidwood in 1877 to work the coal mines (at the rate of seventy cents a ton) during a long and bitter strike. While many were former slaves and farm laborers inexperienced at mining, others had been brought from mines in Indiana. Some fled to neighboring towns due to low pay and confrontations with whites; others simply returned home. But about 200 remained in Braidwood when the strike ended, forming the nucleus of a community. Their descendants still reside there.

By 1880, 386 blacks lived in Braidwood, by far the largest contingent in the county (by contrast, Joliet counted 98 black residents that year). They initially faced prejudice and discrimination; yet, like white ethnic groups, blacks formed their own religious and fraternal organizations and participated in local politics, union affairs, and education. In the late 1870s, blacks began joining local miners' unions, led by Daniel McLaughlin. In fact, early leaders of the United Mine Workers—an organization born in Braidwood—and the union's predecessors welcomed blacks.

Over the next two decades, large numbers of blacks—not all strikebreakers—went to work for mines in surrounding towns, and Braidwood's black population declined. By the turn of the century, black and white miners stood together to oppose wage cuts, long hours, dangerous conditions, company stores, and sporadic employment. As northern Illinois coal mines played out by 1920 and the region's manufacturing base expanded, many black families moved to Joliet to seek other forms of employment.

The Great Migration from the South to the North had an impact on Joliet, as it did on other cities. Higher demand for labor during the war years, the city's location along rail and highway routes, and the increased use of labor-saving agricultural machines in southern states, spurred an upsurge in Joliet's black population. In the first half of the twentieth century, many found work in the steel mills and rail yards. In 1950, there were 1,965 blacks living in Joliet; in 1970, there were 9,507. By 1980, Joliet's black community numbered 15,672; and African-Americans now account for about twenty-five percent of the city's population.

Joliet's African-Americans have not been exempt from civil rights struggles. The local NAACP chapter has fought for equal access to public pools, for desegregated schools, and for equal employment, housing, and educational opportunities. The civil unrest that followed the assassination of Dr. Martin Luther King, Jr., in April 1968, while causing property destruction, had some positive results, especially in regard to jobs and education.

18

Saul Trail 1996

New Street at the pedestrian
crossing for Union Station

12' H x 24' W
acrylic on concrete

Lead Artist:
Javier Chavira

Assistant Artist:
Sergio Gomez and Ilario Silva

This mural depicts various aspects of the Joliet area's Native American heritage. It prominently features a map of the Upper Midwest showing rivers and the Great Sauk (or Sac) Trail, which many tribes used to traverse Will County. The work also includes the portrait of a Potawatomi child, plants and other natural materials the Indians used for food and shelter, and a mother and infant in forced flight from Illinois. The painting is rendered largely in earth tones—browns, greens, and ochres—to underscore Native Americans' relationship to the land.

Native Americans have occupied what is now Illinois since the late Ice Age, or Pleistocene Period, some 12,000 years ago. With the retreat of the glaciers, Paleo-Indians began settling in northern Illinois in large numbers circa 8000 B.C. The Hickory Creek area just east of Joliet boasts two significant archaeologi-cal sites: the Oakwood Mound, a partially excavated burial place dating to the Late Woodland Period (about A.D. 1000); and the Higginbotham Woods Earthwork, an earthen embankment that probably belongs to the Hopewell Period (200 B.C.– A.D.400), when earthworks of a similar type were created along the Illinois and Des Plaines Rivers (and throughout the Midwest).

Since the 1600s, many different Indian nations have made the Upper Illinois River region their home, first and foremost the Illinois. After the Illinois departed the area because of intertrib-al warfare and the general westward spread of European settlers, several other Algonquian-speaking peoples extensively utilized what is now Will County, most prominently the Potawatomi and the associated Ottawa and Ojibwa.

The Potawatomi, formerly of the Upper Great Lakes, was the

Sauk Trail

81

last and largest tribe to inhabit the region. Many of these semi-sedentary Indians lived in small villages on lands adjacent to Hickory Creek near the Sauk Trail, primarily in what are now Joliet and New Lenox Townships. Here they hunted, fished, farmed, gathered berries, and fashioned flint works from the nearby hills, maintaining friendly contact with local settlers. Leafy food crops important to the Potawatomi are shown in the mural—corn, squash, and melons. Also depicted are their wigwam homes, built with a framework of tied bent saplings, and covered with woven grass mats, bark, or animal skins.

The Sauk Trail was a major Midwestern route, traversing the Illinois Basin. Perhaps originally made by wild game like buffalo, the trail was blazed by the Sauk Indians on journeys from their village of Saukenuk (near Rock Island on the Mississippi River) to Fort Malden at Amherstburg, Ontario (near Detroit), where they received annual payments from the British government. Other local tribes, as well as the eastern Iroquois and plains Dakota (Sioux), traveled the route on war and trade expeditions.

From the east, the Sauk Trail—worn as much as two feet below the prairie in some places—passed through Niles (Michigan), Michigan City, and LaPorte. It entered Will County along Hickory Creek, forked across the Des Plaines River through Joliet, then roughly followed what is now the Lincoln Highway, or U.S. Route 30, toward Plainfield. In the 1820s, the Sauk Trail was used as a military highway between Detroit and Chicago, and also was the main route traveled by Joliet's early settlers. In 2000, Congress voted the Lincoln Highway to be a National Scenic Byway.

The Black Hawk War, the conflict named for the Sauk leader, hastened the departure of Native Americans from Illinois, as shown by the downcast figure on the right side of the mural. The war ensued in 1832 when Sauk and Fox allies clashed with settlers over ceded Illinois land. But Potawatomi chief Shabbona opposed the war, and warned whites of possible attacks. Joliet residents hastily constructed "Fort Nonsense," so named because it lacked provision for water, fuel, and food.

After Black Hawk was defeated, the government forced Indians to sign the Treaty of Chicago in 1833, ceding the rest of their lands. The last Native Americans left the Illinois region two

years later. They were moved to Kansas, Missouri, and Iowa, and later were settled in Oklahoma.

The Sauk Trail could still be traced as late as the 1870s; but it and other trails were eventually replaced by canals, railroad routes, and concrete roads. And while some Will County residents still claim a Native American heritage, little remains of the area's early Indian history save for mounds, artifacts, and place names on maps—like the map depicted in this mural, which pays Joliet's original settlers deserved memory.

A Potawatomi baby wears a traditional turban.

Hickory Creek in the 1830s
1996

New Street at the pedestrian
crossing for Union Station

12' H x 24' W
acrylic on concrete

Lead Artists:
Kathleen Farrell
and Kathleen Scarboro

Assistant Artists:
Carla Carr, Javier Chavira
and Sergio Gomez

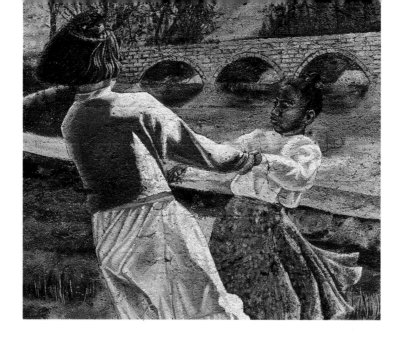

This mural portrays the early mills of Joliet along Hickory Creek. Images of the original Red Mill and the Cagwin Saw Mill, as well as of the old Richards Street stone bridge, are combined with serene scenes illustrating the Hickory Creek area's use by pioneers (and later generations) as a site of recreation and leisure.

Because of its location along the Sauk Trail due east of town, whites settled on Hickory Creek (in what are now Joliet and New Lenox Townships) as early as the late 1820s. Like the Native Americans before them, settlers—who lived in log cabins and "old Indian bark shanties"—were attracted to the area because of its rivers, streams, and woodlands: water was harnessed to power mills, and trees provided lumber. In any settlement, grist (flour) and sawmills were among the first signs of pioneer enterprise. The construction of a mill involved damming a stream and digging a millrace—the current that drove a wheel.

The first mill to appear in the Hickory Creek Settlement was built in 1830 by Colonel Sayre, one of the area's earliest settlers. The mill supplied lumber for Hickory Creek's—and Joliet's—first frame houses, and also served farmers who came in wagons with grain for grinding. What later became known as the Red Mill Company stood on the site, near the U.S. Route 30 entrance to Highland Park. The mill was rebuilt (though it was no longer red) in 1890 following a fire; another fire destroyed the mill around 1930.

John Norman built a small gristmill on Hickory Creek in 1833–34, the first in Joliet Township. It was a primitive log structure, and it never produced more than fifteen bushels of grain a day. Another early sawmill was constructed by A. Cagwin in the 1830s, also on Hickory Creek. This mural pictures the inner workings of the Cagwin Saw Mill, which also cut lumber

Hickory Creek in the 1830s

for early houses in the area. James McKee built the first mill in Joliet proper, on the Des Plaines River, in 1834.

The Joliet area's first bridge was built across Hickory Creek in the 1830s, too. The bridge—a crude affair made of logs—was near John Gougar's cabin (namesake of Gougar Road). Many early bridges—even the sturdier wooden ones that began to be built across the Des Plaines River in 1837—were often threatened by flooding and eventually washed away. Such bridges were followed by more durable structures like the Richards Street stone bridge, shown in the mural.

Children at play on the water's edge allude to settlers using Hickory Creek as a recreational area. It was also an early farming area, and as agriculture became more commercial by the mid-nineteenth century, several more gristmills sprang up along the stream and river. Hickory Creek is still a place for play, as it winds through Pilcher Park and Higginbotham Woods.

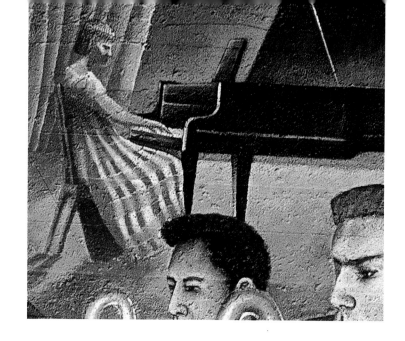

Joliet's Love of Music 1996

Northwest corner of Michigan
Street at Van Buren Street

10' H x 12' W
acrylic on concrete

Lead Artist:
Sergio Gomez

Assistant Artist:
Javier Chavira

This lyrical mural honors the musicians in the bands, orchestras, and ensembles of the Joliet area. Largely because of the superior training that students have received in the integrated band programs of Joliet high schools and grade schools, the city has produced many renowned musical performers, composers, and educators. As a result, music—whether big bands, classical, opera, jazz, pop, rock, or blues—has become an essential part of the everyday life of the community, a deeply rooted feature of civic culture and pride.

The artwork is appropriately dominated by horn-blowing members of the Joliet Township High School Band. By the late 1920s, it was known as the best high school band in the nation, eventually rising to international prominence and helping to earn Joliet the sobriquet "City of Champions."

The band was organized in 1912 as an extracurricular activity with twelve secondhand instruments and nail kegs used as chairs. A year later, Archibald R. McAllister became band director, and the band would remain under his baton until his death in 1944. By 1914—when eighteen boys played eighteen instruments purchased by the school board—the band had gained enough prestige to be included in the regular curriculum.

Because of McAllister, Joliet became a respected name in the band world. The Joliet Township High School Band won state championships in 1924, 1925, and 1926, and the National High School Band Contest three years in a row, 1926-1928; none other than John Philip Sousa judged the 1928 contest, which was held in Joliet. That year, the school was given permanent possession of the national championship trophy (which, along with other trophies, is proudly displayed in a special case at Joliet Central). In 1929, the band was barred from competition for one year as a favor to other bands. But it won again in 1931,

Joliet's Love of Music

was barred again in 1932, and won yet again in 1933.

The band was not the school's only outstanding musical group: the Joliet Township High School Orchestra, formed in 1912, also won state championships in 1930 and 1931. For many years the Joliet Grade School Band, under the direction of Charles F. Peters, was considered the country's strongest grade school program. In fact, a documentary on the band included the statement that Joliet children were "teethed on oboe reeds." The music programs of Joliet West High School and the now-defunct Joliet East have, as well, produced outstanding musicians.

During the 1930s and early 1940s, A. R. McAllister took his band on concert tours throughout North America—from Mexico to Canada, in the U.S. from New York to California, as well as on countless trips to Illinois cities. On a 1936 tour that included New York City, the band performed at the Metropolitan Opera House, Madison Square Garden, and Radio City Music Hall, where box office records were broken. The band also played for every group of departing Joliet servicemen during both World Wars, a record McAllister—who was also

founder and president of the National High School Band Association—felt was his most important achievement. In later years, the band played for those departing to serve in the Korean and Vietnam Wars.

The beloved bandmaster died in 1944, at age 63. He is honored by a showcase of mementos outside Joliet Central's band

Sergio Gomez

Born: **Puebla, Mexico 1971**

Education/Experience: **M.A. and B.A., painting, Governors State University, 1998 and 1996; painted murals since 1994.**

Current status: **graphic designer, Lansing, Illinois.**

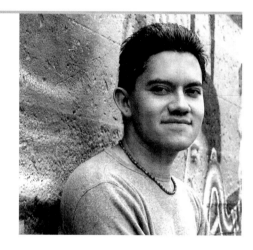

room. After World War II, returning veterans organized the Joliet American Legion Band, under the direction of A. R. McAllister, Jr. Many graduating high school band members have gone on to join the Legion Band, which has won dozens of state and national championships since 1946. It continues to have an active schedule of concerts, parades, and contests.

In 1945, Bruce Houseknecht assumed direction of the Joliet Township High School Band, which continued to tour and perform at numerous national clinics and contests. The band also played for many presidents; in January 1953 it received one of its most distinguished honors when it was awarded First Prize in Dwight D. Eisenhower's Inaugural Parade.

Theodore Lega, a student of Houseknecht's, became band director of Joliet Central High School in 1969 (the school system had decentralized some years earlier). The band's winning tradition includes consistent superior first-place rankings in Illinois High School Association music contests, and numerous first-place and grand championship awards at state, Midwest, and national competitions. In addition, the band has either won first place or been an honor band thirteen times in the University of Illinois-sponsored Super State Competition, and has been grand champion at the Illinois State University contest ten times since its inception in 1987. McAllister, Houseknecht, and Lega

have all been elected into the prestigious American Bandmasters Association.

Among the notable musical performers, educators, composers, and bandleaders to come out of Joliet High School music programs are (in no particular order): Major Mark Peterson, division chief for U.S. Air Force bands; Richard Drew, a U.S. Air Force Band director; Peter LaBella, Lyric Opera of Chicago violinist; Marcia LaBella, Chicago harpist; Russell Dagon, former Chicago Symphony Orchestra clarinetist; Devere Moore, former Chicago Symphony Orchestra oboist; Jeff Ray, Lyric Opera of Chicago vocalist; Juliet King, opera vocalist; Michael Jolthen, composer and clinician of choral works; Rick Blatti, Ohio State University music director; Dean Sayles, former president of the Illinois Music Educators Association; son Joel Sayles, a Minneapolis record producer; Forrest McAllister (son of A. R.), longtime publisher/editor of *School Musician* magazine, once published in Joliet; the late Henry T. Lega, director of Teddy Lee Orchestra (now carried on by son Theodore Lega); Steve Rodby, bass player with Pat Metheny; Donna Shea, jazz violinist; Anthony Rapp, Broadway performer; John Barrowman, Broadway performer; Lionel Ritchie, pop vocalist; as well as an extensive list of university music professors and high school and elementary band directors.

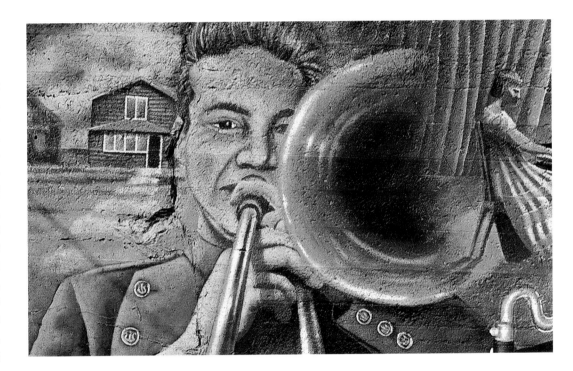

㉑
La Katerina: Katherine Dunham
1996

Southwest corner of Michigan
Street at Clinton Street

10' H x 12' W
acrylic on concrete

Lead Artist:
Javier Chavira

Assistant Artist:
Sergio Gomez

This mural is a tribute to Katherine Dunham, a one-time Joliet resident who is among the most influential figures in twentieth-century art. A dancer, choreographer, actor, anthropologist, author, and activist, "La Katerina," as she was affectionately called, raised African/Caribbean dance traditions to a modern art and has inspired generations of people throughout the Americas and the world.

The painting shows a young and graceful Dunham, ornamented with Haitian symbols, striking a dance pose in front of an African mask backdrop; surrounding decorative designs and patterns highlight Dunham's multicultural heritage, as well as the many cultures to which she brought a love of world dance. The bottom inscription reads: "Artist/Humanitarian Bridging Cultures Together Through Dance."

Dunham was born in Glen Ellyn, Illinois, in 1909 of African-American, French-Canadian, and Native American ancestry. When she was five, Dunham moved with her parents to Joliet, where her father opened a dry-cleaning shop. An exceptional athlete, Dunham first studied dance at Joliet Township High School and Joliet Junior College. She moved to Chicago in 1927

La Katerina Katherine Dunham

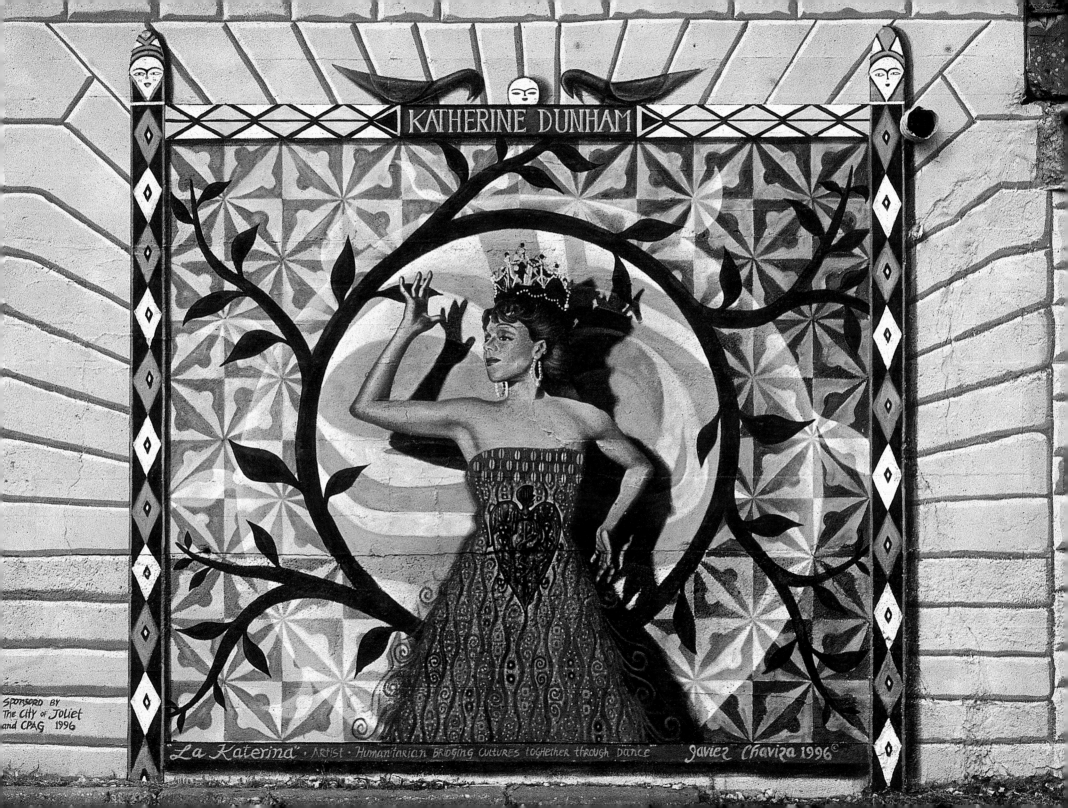

KATHERINE DUNHAM

Sponsord By
The City of Joliet
and CPAG 1996

"La Katerina" · Artist · Humanitarian Bridging Cultures together through dance Javier Chavira 1996

Javier Chavira

Born: Villa Juarez, S.L.P., Mexico 1971

Education/Experience: M.A. and B.A., painting, Governors State University, 1999 and 1996; painted murals since 1994.

Current status: studio painter and sculptor, enrolled in M.F.A. painting program, Northern Illinois University; FCPA artist, Joliet, Illinois.

One of the biggest rewards of being an artist working in Joliet is the reaction you get from the average person whose only access to art is the murals that celebrate our city. Their positive reaction gratifies and gives me the motivation I need to create work that speaks to all walks of life.

and studied tap-dancing, ballet, and acting. In the early 1930s, she opened a dance school and performed at the Chicago Opera House and the Chicago World's Fair. In 1935, while attending Northwestern University, she won a grant to tour the West Indies and study Afro-Caribbean dance, religion, and folklore. A year later she received a degree in social anthropology from the University of Chicago.

Dunham developed her unique combination of traditional ballet and African dance forms as dance director for the Works Progress Administration's Federal Theatre Project in Chicago. In the late 1930s, her troupe performed in New York, Chicago, and at various places in Illinois, including a high school scholarship benefit in Joliet. She also choreographed dance scenes for Warner Brothers movies, and lectured and wrote on anthropological subjects.

In 1940, Dunham's all-black musical drama *Cabin in the Sky* was staged on Broadway and in San Francisco. During the war years, her dancers toured North America; yet, despite the acclaim, they faced prejudice and discrimination as they sought accommodations on the road. Dunham sued hotels in Chicago and Cincinnati. In 1943, she appeared in the black movie classic *Stormy Weather* with Lena Horne, Fats Waller, and Cab Calloway.

Dunham opened the Katherine Dunham School of Dance in

New York in 1944, which remained in existence for a decade. Over the next 16 years, the Katherine Dunham Dancers appeared in films, plays, and television specials, and recorded albums while also touring to rave reviews in Mexico, Latin America, Western Europe, the Near and Far East, and Australia and New Zealand. Dunham also wrote five books, including the 1959 *A Touch of Innocence*, a searingly honest account of her early life. She established a second residence in the historic Habitation Leclerc estate in Port-au-Prince, in her beloved Haiti.

Since 1967, Dunham has lived in East St. Louis, where she has been affiliated with Southern Illinois University. She founded the East St. Louis Center for the Performing Arts, the Katherine Dunham Children's Workshop, and a museum that holds items from her troupe and its travels. She has received numerous awards and continues to maintain an active interest in civil rights and national affairs. In 1992, she went on a forty-seven-day fast to protest U.S. policy on Haitians who were refused entry into this country. Dunham has lived in the same two-story brick house for over three decades.

Katherine Dunham currently lives in Southern Illinois.

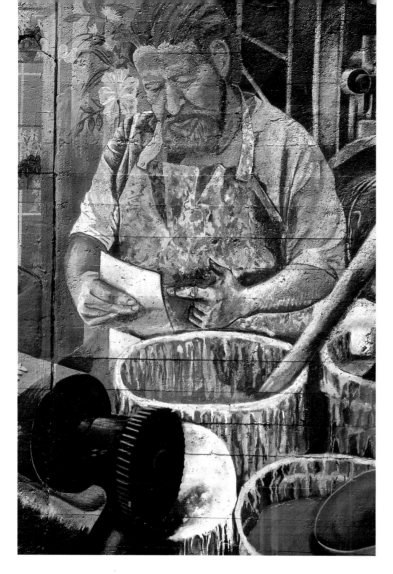

22

Papering the World:
Joliet's Wallpaper Industry 1996

Northwest corner of Michigan Street
at Cass Street

12' H x 32' W
acrylic on concrete

Lead Artists:
Kathleen Scarboro
and Kathleen Farrell

Assistant Artists:
Carla Carr, Dante DiBartolo,
Jeanne Zimmerman and Eric Frazer

This mural honors the wallpaper industry in Joliet, which in the early decades of the twentieth century was the nation's largest producer of wallpaper. The painting, which illustrates workers and artisans designing and manufacturing this important decorative household product, also is considered one of the Midwest's preeminent examples of labor-oriented public art. Rich in color and detail, as well as in its depiction of an industrial milieu, the mural reminds viewers that wallpaper is as much a part of Joliet history as stone and steel.

Based on composite photographs, the artwork features several aspects of local wallpaper production. On the lower left, a solid maple roller used to print wallpaper is covered with inlaid brass to increase its resistance to pressure. Up to twelve rollers were used for each design, some of which were engraved by Joliet artisans. The rollers took three months to carve and cost $1,000 apiece.

Behind paint vats, a worker is shown mixing colors to specification for a press run. Another worker passes paper through a Waldron Printing Press, which had print stations ranging from one to twelve, depending upon the number of colors in the pat-

Papering the World

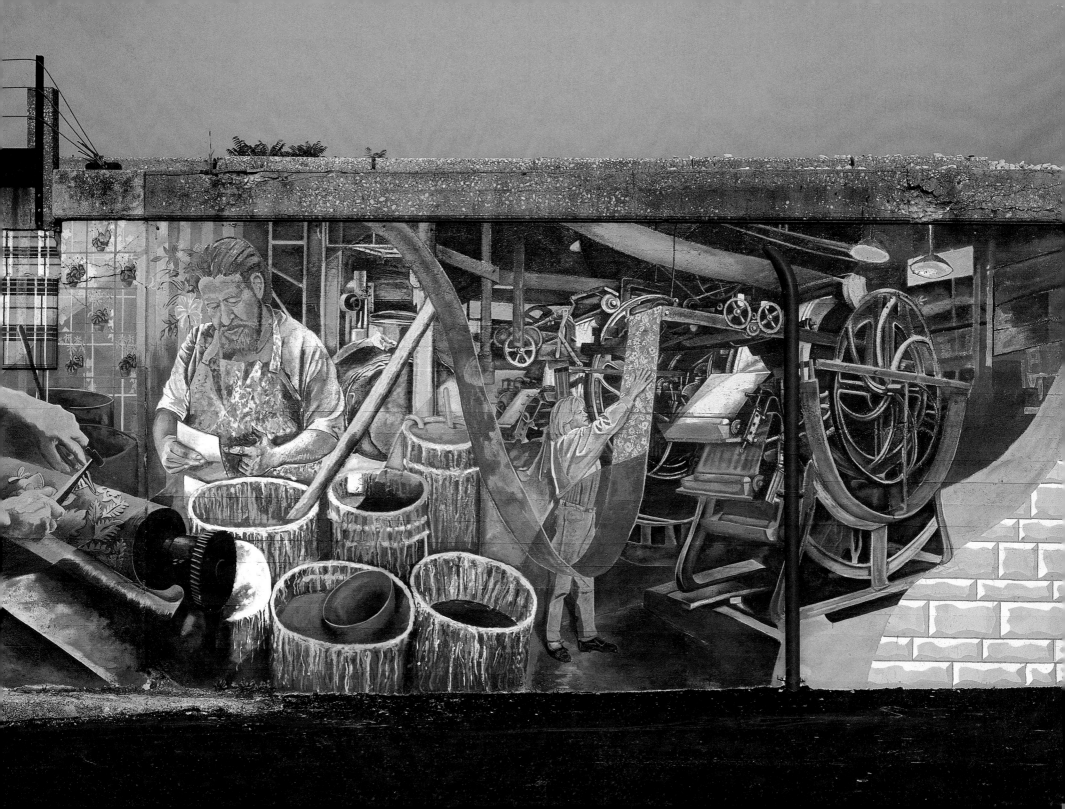

This is an original Lennon Wallpaper 1890 press still in use today at Mokena Mills.

tern. Several examples of patterns designed and printed in Joliet appear on the upper left. Inscribed on a banner of paper to the right are names of Joliet's wallpaper producers.

The industry began locally in 1907 when Frank J. Kelley moved his business from Chicago to Joliet because overhead costs were less expensive. His Star-Peerless Wallpaper Company, located on Maple Street, was an immediate success. Over the next fifteen years—owing to the city's central national location, low corporate taxes, available workforce, rail transportation, and proximity to the Chicago market—five companies followed suit: Joliet Wall Paper Mills, Lennon Wall Paper Company, Midwest Wall Paper Mills, Superior Wall Paper Company, and the United Wall Paper Factory, Inc.

In 1918, women at Star-Peerless organized a union and tried to negotiate a union contract. When the company refused to recognize the workers' right to organize, they went on strike; some were arrested for picketing the workplace. Labor activist Mary "Mother" Jones came to Joliet and addressed the strikers.

By 1930, Joliet was known as the "Wallpaper Capital of the World." At their peak, the six mills employed 1,000 men and women who produced over 100 million rolls of wallpaper a year—one-third of the country's total annual output. Each working day, Joliet plants manufactured enough wallpaper to

stretch from New York and back! In later years, three more facilities were established—Morgan-Gardner, Atlas, and Mokena Mills (the only one still making residential wall coverings in Will County).

"There is no possibility of this product becoming obsolete or danger that the use of wallpaper will decline," a local newspaper confidently stated in 1939. But decline it did, beginning in the late 1950s. Latex paint, wood paneling, and the conversion from coal to natural gas in heating homes, led to the demise of the wallpaper industry; cleaner gas furnaces reduced the frequency of redoing residential walls.

The last and largest plant in Joliet was the Lennon Company. Acquired in 1981 by a company that was later bought out by North American Decorative Products, the Lennon mill continued to manufacture "machine-printed wall coverings designed and styled for the do-it-yourself and mass markets" until 1988, when its operations were moved to nearby Shorewood and then consolidated in Canada. Lennon's final president, Dennis Maiotti, soon reopened the Mokena Wallpaper Company as Mokena Mills.

This striking series of murals, designed by Kathleen Farrell and Kathleen Scarboro, stretches nearly two blocks along the south side of West Jefferson Street between Bluff and Hickory Streets. Bluff Street paralleled a portion of the Great Sauk (or Sac) Indian Trail, which, besides being used by a succession of Native American tribes, was also the route traveled by many of the Joliet area's earliest settlers. Charles Reed, generally considered the town's founder, built a log cabin near the southeast corner of Exchange (Jefferson) and Bluff Streets in 1832; by the mid-1830s, Bluff Street had become Joliet's principal business district.

(A note on the city name: When the village was platted in 1834, the Board of Canal Commissioners recorded it as "Juliet" because settlers had already been calling it that. They had taken the name from an old mound that early mapmakers had labeled Mound Juliet, a misspelling of the explorer's name. Although cartographers began changing the mound's spelling to Joliet in the 1830s, the town remained Juliet until 1845 when it was officially changed.)

The Bluff Street murals present a montage of scenes depicting early life, livelihood, buildings, and businesses along Joliet's first commercial corridor. The murals are interpretations of historical photographs and documents furnished by the Will-Joliet Bicentennial Park Corp. and feature actual townspeople as models for prominent settlers and citizens. For the most part naturalistically rendered, with scenes dissolving in and out of each other through space and time, these murals succeed in evoking a "dreamlike memory of the past" and in bringing Joliet's early heritage vividly alive—and very near the site where settlement began. In fact, many of the people, places, and events depicted in these works are marked in Billie Limacher Bicentennial Park with bronze plaques on boulders.

Bluff Street

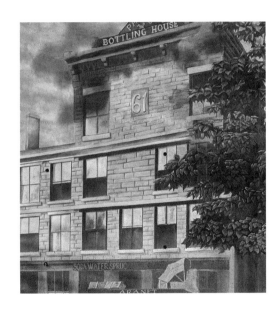 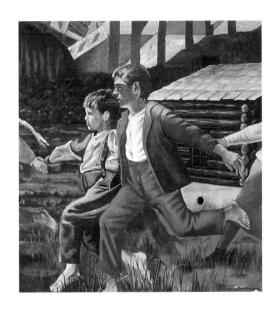 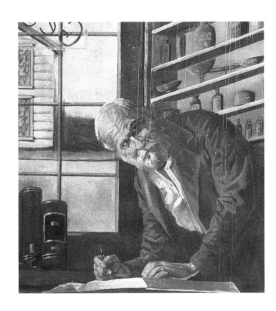

㉓

Bluff Street Architecture in 1840
1995

South side of West Jefferson
Street at Bluff Street

20' H x 70' W
acrylic on concrete

Lead Artists:
Kathleen Scarboro
and Kathleen Farrell

Assistant Artists:
Sergio Gomez, Javier Chavira,
Carla Carr, Jesus Rodriguez
and Eric Standish

Starting at the east end of the block, this mural depicts a nostalgic panorama of life (and architecture) along Bluff Street. It highlights Merchant's Row which, between 1837 and 1899, transformed the district from a tranquil settlement into a prosperous city.

The first edifice, on the left, is part of a historic building known as Merchant's Row. The block was built in 1837 by Martin H. Demmond, who had arrived in Joliet several years earlier, and Merchant's Row was the city's third stone building. A businessman and developer, Demmond was the first to quarry limestone from nearby bluffs—he built the block with stone right from the site. Originally 120-feet long and three-stories high, Merchant's Row consisted of six stores on the ground floor, with offices, residences, and public halls on the second and third floors.

In 1859, John D. Paige established Paige's Bottling House in the part of the block pictured in this mural. A community leader and politician, Paige is often credited with bottling the first soda pop in the U.S. Paige built the fourth floor over his portion of Merchant's Row to accommodate his family. He also added an underground storage area and stairway to the rear of the building. The stone grotto and steps shown in this mural are the sole surviving remnants from this era; they have been preserved and renovated as a historic site. Paige later sold his business to A. Ranft Bottling Works, whose horse-drawn wagon is pictured in front of the building.

At the top of the mural is a part of the Des Plaines River, showing Bluff Street's River Block. The block—destroyed by fire in 1886—housed many important businesses, such as the Leach Windmill Co. and the E. Porter Brewing Co, with its twin cupolas.

The next large structure is the American House Hotel, believed to be part of the Underground Railroad system for fugi-

Bluff Street Architecture in 1840

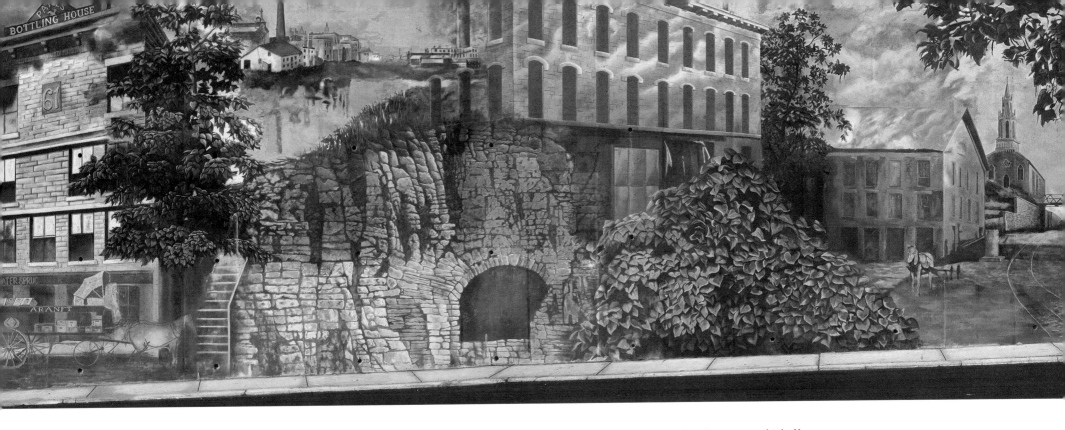

tive slaves before and during the Civil War. To the right of that is a depiction of Joliet's first stone building. Located at the southwest corner of Bluff and Exchange (Jefferson) Streets, the forty-foot-long structure was built by Demmond in 1835. The enterprising stonemason moved his general store into one of the two ground-floor spaces, renting out the other one. More than anything, Demmond's stone buildings, including Merchant's Row, provided the impetus for the early development of Bluff Street—and Joliet.

At the end of the mural, on the right, is the original St. Patrick's Church on Broadway Avenue, Joliet's first Roman Catholic parish. It was built between 1839 and 1848 to accommodate the Irish who had arrived in large numbers to dig the Illinois & Michigan Canal.

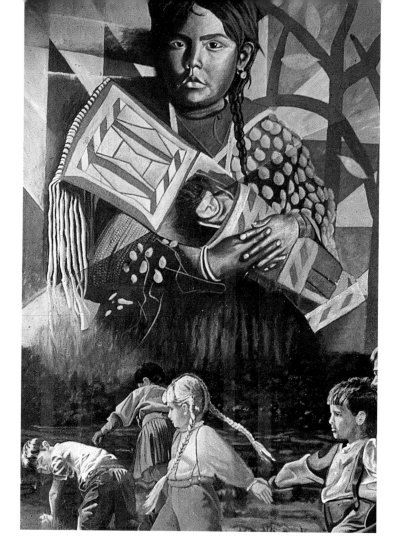

24

A Patchwork of Hearth and Home:
Women and Children of Bluff Street
1995

Under the Broadway Street overpass
on the south side of West Jefferson

20' H x 70' W
acrylic on concrete

Lead Artists:
Kathleen Scarboro
and Kathleen Farrell

Assistant Artists:
Javier Chavira, Sergio Gomez,
Carla Carr, Jeanne Zimmerman
and Dante DiBartolo

True to its title, this mural presents a patchwork of cultures, designs, and images, particularly honoring the roles that women and children played in pioneer-era Bluff Street. Early American quilt patterns interweave to create a backdrop for scenes of home life and other domestic activities.

In the upper left, the image of a young Potawatomi woman coddling an infant serves as a reminder that the area was first inhabited by Native Americans, some of whom had contact with early settlers. The scene of children playing "crack the whip" in front of Charles Reed's log cabin—Joliet's first home, built in 1832—pays homage to a painting by American artist Winslow Homer. Right above it is Fort Nonsense, so named because of its uselessness; it was hastily constructed atop Bluff Street, without access to food, fuel, and water, in 1832 during the Black Hawk War. But Indians never raided Joliet, and the fort, ironically, later served as the area's first school. Pictures of kerosene lamps, a mother and daughter embracing, and a woman in her kitchen further evoke the flavor of daily frontier life.

A Patchwork of Hearth and Home

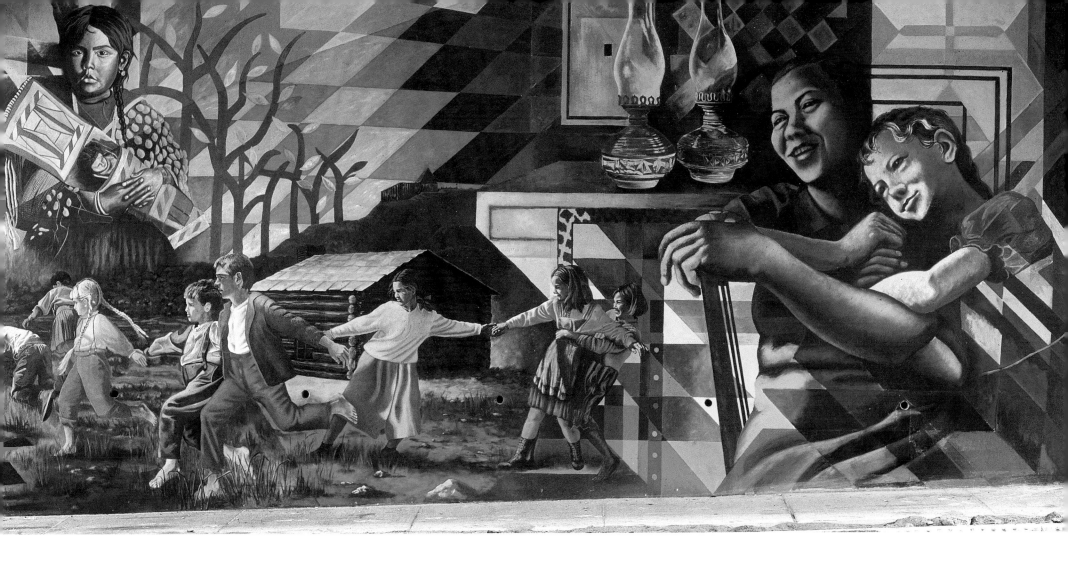

Women and Children of Bluff Street

Bustling Bluff in the 1800s
1995

South side of West Jefferson Street
between Broadway Street and
Hickory Street

13' H x 273' W
acrylic on concrete

Lead Artists:
Kathleen Scarboro
and Kathleen Farrell

Assistant Artists:
Dante DiBartolo, Carla Carr, Marion
Kryczka, Jesus Rodriguez, Eric Standish,
Sergio Gomez and Javier Chavira

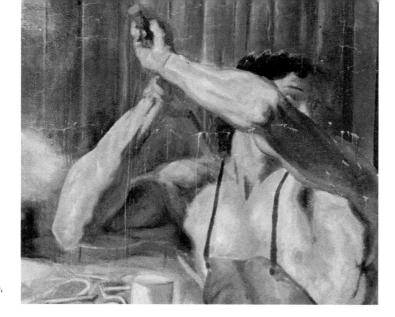

This series of six interlocking scenes is a tribute to the resourcefulness and courage of Joliet's early citizens, and highlights various activities—commercial, industrial, and cultural—that made Bluff Street such a dynamic chapter in local history. The block-long mural, which truly functions as commemorative art, is also a tribute to the resources and industry of its creators, as the work ranks among the longest continuous murals in the Midwest.

Beginning at the left is a depiction of the National Hotel, which was built in 1837-1838 and played a major role in the early history of Joliet and the Illinois & Michigan Canal. Its notable guests included Abraham Lincoln, Horace Greeley, and Meriwether Lewis (of Lewis and Clark). The hotel stood on the southeast corner of Bluff and Exchange (Jefferson) Streets for 120 years before it was destroyed by fire in 1958.

Framed against a background of limestone bluffs and catalpa trees, bottler John Paige (with beard) is shown posing with three of his workers. Originally from Jefferson County, Wisconsin, Paige became one of Joliet's leading citizens, serving as police chief, fire chief, and mayor. He is best remembered for creating the first carbonated beverages in the country. Paige bottled flavored water under pressure, using carbonic acid gas "to impart health giving qualities and a brisk refreshing taste to the beverage," as his ads said. He did not patent carbonation—he had merely applied an existing process to flavored water—but did open similar businesses in at least two other cities.

The second scene depicts two early businesses, Reimer's Sash and Door Co. and the Wagner Carriage Co., as well as Demmond's stone works. Before the onset of automobiles, most people relied on horse-drawn vehicles as their principal means of transportation. Consequently, carriage making was an important business, and many people engaged in this livelihood over

Bustling Bluff Street in the 1800s

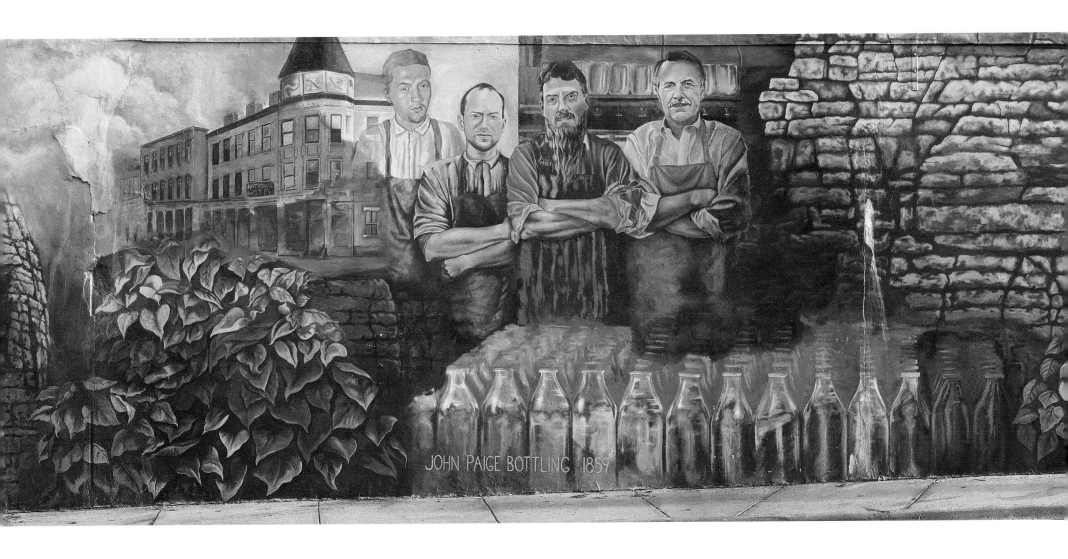

JOHN PAIGE BOTTLING 1859

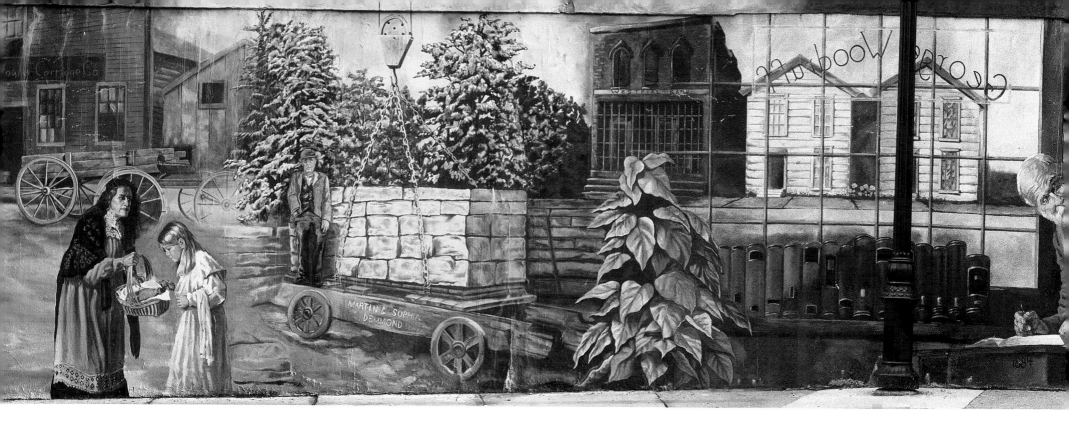

Local historians Billie Limacher and Mel Schroeder posed as Mr. & Mrs. Demmond.

the years. Deacon Beaumont was the village's first producer of carriages, wagons, and buggies, but shown here is Paul Wagner's establishment, along with two of his models. A boulder in Billie Limacher Bicentennial Park marks the site of Wagner's former shop and the grove of catalpas that he and his wife planted in the 1860s.

Completing the scene, Sophia Demmond is shown bringing a lunch basket to her husband Martin, as was the custom of many women of the day. Martin is shown standing on a wagon load of freshly quarried limestone. The Demmonds came to Joliet in 1834. Martin is credited with being the area's first stonemason, platting what was originally called West Juliet, and laying the foundation (literally and figuratively) for the city's business and industry. Sophia is pictured with her niece Kate Murray, who later married local Civil War hero Colonel Frederick Bartleson. He was just one of many Joliet citizens who fought in the war.

The third scene commemorates George H. Woodruff, among Joliet's most honored early citizens. He settled here in 1834,

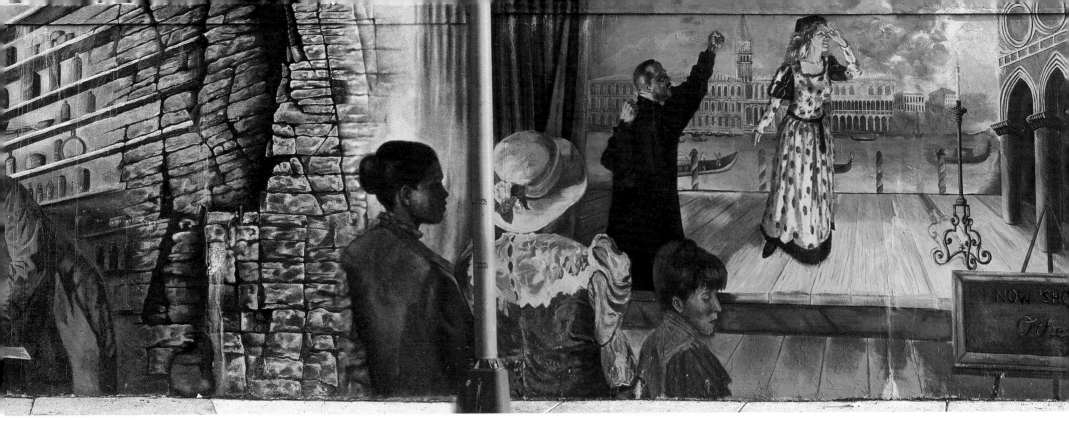

established an apothecary shop on Merchant's Row, and held many offices in city and county government. Woodruff is best known as the first historian of Joliet and Will County, writing several books in the 1870s and 1880s. The *History of Will County, Illinois*, published in 1878, reprinted in 1973, and still sold in town, weighs in at a thousand-odd pages.

Woodruff is depicted here working on a historical tome in his last drug store, at the northeast corner of Bluff and Exchange Streets. In the window behind him are the German Loan and Savings Bank (commonly known as the old Westphal Bank), built in 1875 and demolished in 1968, as well as a set of Joliet's unique twin houses.

Bluff Street was not just an arena of work and commerce; the arts also played a vital part in settlers' lives. The fourth scene portrays Joliet's first theater, which was on the third floor of Merchant's Row. It was used by local and touring performing artists, as well as for debates, meetings, and church services. Among the first productions staged in the theater by a profes-

A scene from Othello, performed in 1840 at Joliet's first theater, is reenacted.

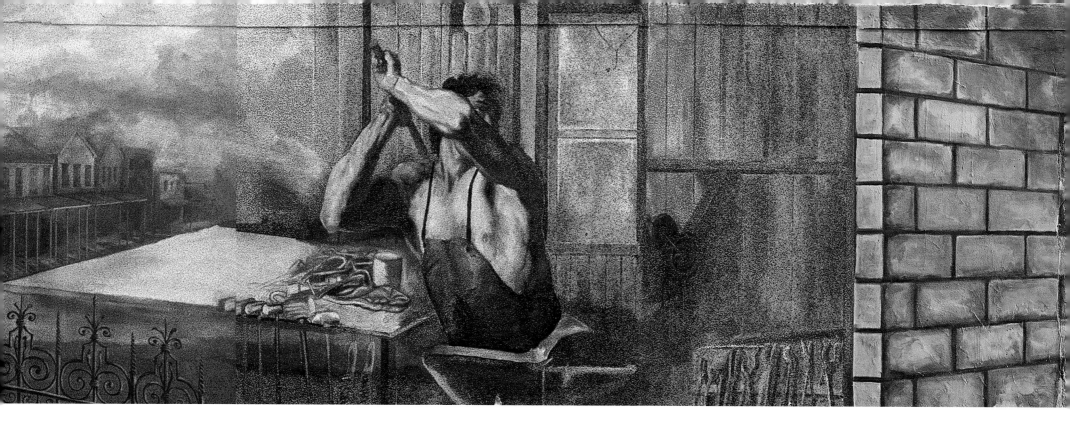

sional traveling company was Shakespeare's "Othello," in 1842, as pictured here. With Venice as a backdrop set, Othello is shown trodding the boards with long-suffering Desdemona. "Though enlivening at times," recorded Woodruff, "it left something to be desired."

The fifth scene depicts a block of businesses on the northwest corner of Bluff and Exchange Streets, including Barrett's Stove, Iron and Tin Shop. The shop was located on the same site as the city's first hardware store, which later evolved into the Barrett Hardware Co. Blacksmiths played an important role in the com-

munity—William R. Atwell was Joliet's first, in 1834–35, and many more followed. Shown here is a brawny village smithy putting his muscles behind the making of an ornamental wrought-iron fence, pictured along the street in the foreground. The block also housed a general store and a department store.

The sixth and final scene, nearest Hickory Street, depicts a row of buildings south of Jefferson Street on the riverside, including John Theiler and Sons' flour and seed business, retail grocery, and saloon. The town's first newspaper, the *Juliet Courier*, was founded by a group of citizens who sought and

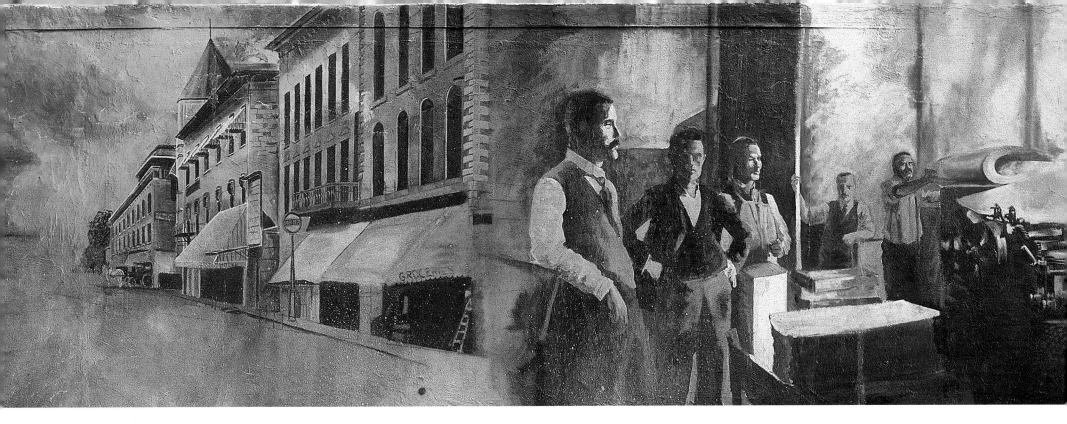

hired O. H. Balch to be publisher, editor, and printer. The paper's original home was Merchant's Row, where its first edition was printed on April 20, 1839; the present-day *Herald News* traces its lineage to the *Courier*. This scene shows pressmen and other paper personnel running the printing press.

Among citizens posing for the Bluff Street Murals were: Jim Haller, Robert Sterling, Billie Limacher, Mel Schroeder, Willa Schroeder, Chris Dragatsis, Javier Chavira, Dante DiBartolo, Sam Carr, Carla Carr, and Mary Scarboro.

Images of Joliet's limestone bluff's separate the scenes of the mural.

From Slovenia to America
1994–1997

East side of Scott Street
at Ohio Street

Ten murals
10' H x 11' W
acrylic on concrete

Lead Artist:
Lucija Dragovan

Assistant Artists:
Lillian Brulc, Robert Baher
and Mollie Gregorich

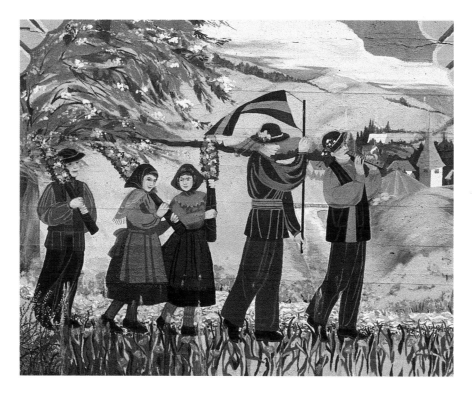

This series of ten murals is a tribute to Joliet's deeply rooted Slovenian community, focusing on the transition from one country—one way of life—to another. The scenes sequentially portray traditional life in Slovenia, emigration from the "old country" to the New World at the turn of the century, the establishment of permanent settlements in Joliet, and the integration into American life. Painted in a clear, unaffected style that evokes European folk culture, the murals depict Slovenian customs and ceremonies, as well as the peoples' work ethic, love of family, respect for home, and

The Procession. Children in a springtime procession are shown carrying *butarice*, or bundles of fruit, flowers, and pussy willows, the earliest plants to sprout in the spring. It is Palm Sunday, and the children are on their way to church to have the bundles blessed. Leading the group are a flag-bearer and a young man playing a recorder. This custom still exists today. Slovenia is filled with flowers, and fresh ones are commonly used for many occasions.

From Slovenia to America

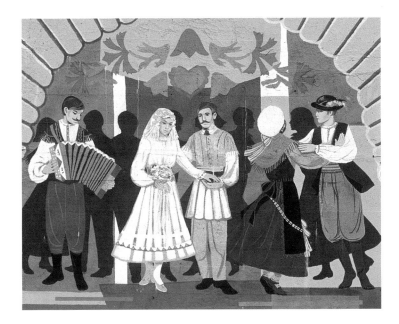

A Slovene *(Ohcet)* **Wedding.** Weddings are festive occasions in Slovenia, with some lasting up to three days. In this scene, a bride and groom step out to dance while a button-box musician plays Slovene songs. Dancers in native costumes swing their partners. The history of Slovenian dance goes back more than 1,000 years, with twirling motions accompanying melodious, sentimental music.

education of children. The scenes are set inside a series of limestone arches recalling those of the old U.S. Steel headquarters building.

Slovenians immigrated to the U.S. and Illinois in three major waves from the late nineteenth century through World War II. Before World War I, Slovenians lived within the boundaries of Austria-Hungary. Economic and political conditions forced many to seek better lives—and better-paying jobs—in other countries; America, above all, was seen as a land of unlimited

ARTIST BIOGRAPHY

Lucija Dragovan

Born: Joliet, Illinois

Education/Experience: B.F.A., Chicago Academy of Art, 1973; additional study, School of the Art Institute of Chicago, 1970s; adjunct faculty, Lewis University, Joliet Junior College; watercolor artist with an extensive exhibition record.

Current status: studio watercolor artist, Joliet, Illinois.

The ten murals are dedicated to the Slovene immigrants who emigrated to the United States: their customs, ceremonies, work ethic, love of family, respect for the home, and especially the education of their children.

My dream since childhood was to design and paint a memorial to my parents, who traveled to America at a very early age. And to dedicate the memorial murals to all the Slovene immigrants who settled and worked in Joliet. The murals have enabled me to realize that dream.

The Harvest. This scene could be taking place at either sunrise or sunset, since Slovenian farmers work throughout the day. The husband and wife are shown gathering grain, while their daughter brings them a basket of food. The *kozolec*, or hayrack, is a symbol of Slovenia, as these are seen all over the countryside. The wagon awaits products from the harvest. Many of the Slovenians who came to America had been farmers and field workers.

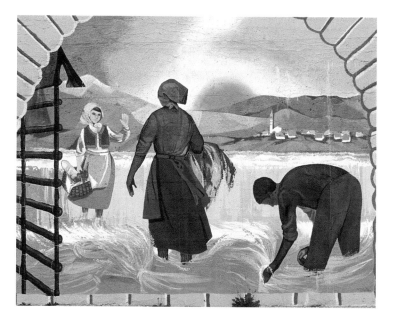

ARTIST BIOGRAPHY

Lillian Brulc

Born: Joliet, Illlinois

Education/Experience: **M.F.A. and B.F.A., School of the Art Institute of Chicago; M.F.A., University of Chicago; national and international commissions.**

Current status: **artist specializing in architecturally related painting and sculpture, Joliet, Illinois.**

It was a rewarding experience working with Lucija on her first four of these ten murals. The Steel Mill composition particularly intrigued me. I had long been interested in seeing a tribute to such workers.

prosperity and progress. By pursuing trades learned in their homeland, and by hard manual labor, Slovenians contributed to the growth of American industry, and settlements in the U.S. began to grow and prosper. Slovenia, long a part of Yugoslavia, gained its independence in 1991.

The Joliet community was known as Slovenski Rim, or Slovenian Rome, because of its deep religious roots. The first Slovenian fraternal organization, later known as the American Slovenian Catholic Union, was founded in Joliet in 1894. The first Slovenian Catholic newspaper was also published here, from 1899 to 1923. Joliet is also the home office of the

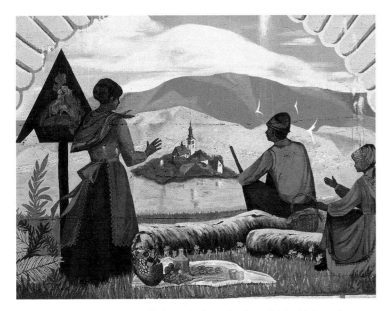

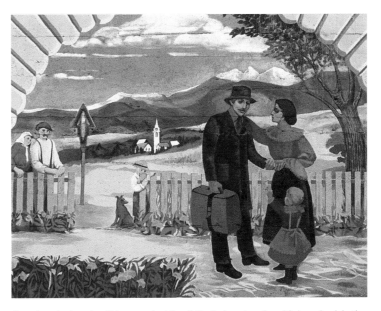

The Picnic. A family is shown enjoying a picnic at the shore of Lake Bled, another symbol of Slovenia. Nestled in a romantic valley, it is among the most famous resorts in the Julian Alps. A *kapelica*, or a memorial shrine with the image of Marija Pomagaj, the patron saint of Slovenia, is to the left of the standing woman.

Departure to America. This scene depicts a father's departure from his homeland. In the background are the well-known Triglav Mountains, a distant foothills village, and a roadside field shrine of the type found throughout the countryside. For many Slovenians, America was the Promised Land, and newcomers were determined to work hard, overcome obstacles, and succeed. Yet Slovenia was a beautiful country, not easy to leave. Red carnations symbolize *Slovenski dom*, or the Slovenian love of homeland.

Slovenian Women's Union of America, founded in 1939.

Markus Krakar was the first known Slovenian to arrive in Joliet, before 1870. He found work in a quarry, and soon saved enough money to buy the works. By 1885, there were forty Slovenians in Joliet, many of whom had established businesses in the thriving colony. Martin Ivec, who immigrated in 1890, is believed to have been the first Slovenian doctor in the U.S.

Reverend Francis Sustersic arrived in 1891 and immediately organized a parish; St. Joseph Church was built the same year on Chicago Street, using limestone donated by Krakar. The second church was finished in 1905. The parochial school was erected in 1895, and by 1916 it had the largest attendance of any school in Joliet. After World War I, many Slovenian immigrants joined the local workforce in mines, mills, quarries, and rail yards.

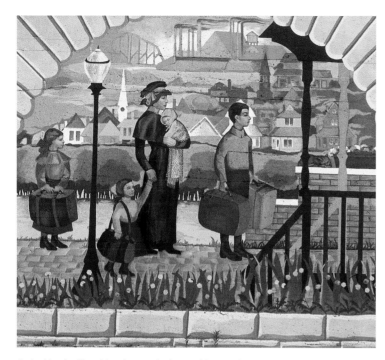

Arrival in the City. After the men had put aside enough savings, they were able to bring their families to America and sometimes build homes. This scene depicts a mother and her children arriving in Joliet. In contrast to the previous mural, set in rural Slovenia, the background shows an industrial American city around 1900, along with immigrant neighborhood homes, church steeples, and the dominating steel mills. Although it was a new and unfamiliar land, recent arrivals could feel at home in Joliet, which had a large and welcoming Slovenian population.

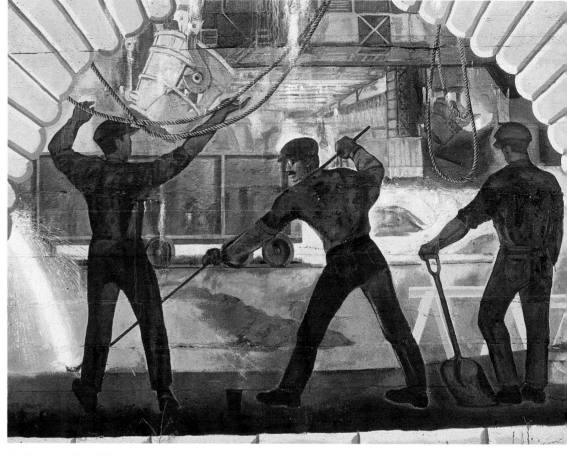

Working in the Steel Mills. This mural is a tribute to the work ethic of the Slovenian men who—like many other European immigrant groups at the turn of the century—were forced to take the hardest jobs and work for the lowest wages. Many Slovenians found jobs in Joliet's steel mills, where the rugged life in their homeland had prepared them for working long hours in intense heat and dangerous conditions in order to provide for their families. Around 1900, pay was from $1.00 to $1.50 for a twelve hour workday in the mills or quarries.

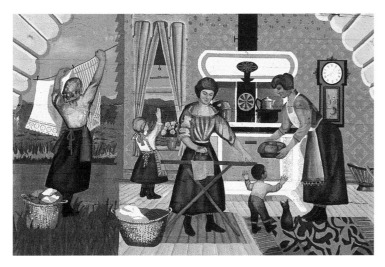

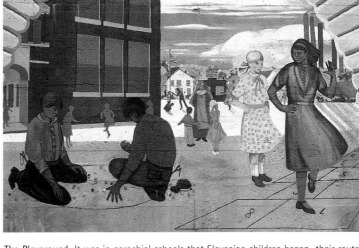

Slovene Home Making. This mural is dedicated to the women immigrants, who were as industrious as the men. This scene shows women working at home, and emphasizes parental love and family unity. In the kitchen, women bake *poticas* (a nut rolled pastry), iron clothes, and tend to their children. While many Slovenians soon became American citizens, many cultural traditions were maintained.

The Playground. It was in parochial schools that Slovenian children began their route to American citizenship. The children of immigrants excelled in classrooms as well as on the playground. Games such as baseball, marbles, hopscotch, and jump rope—all depicted here—were just some of the pastimes that schoolchildren enjoyed.

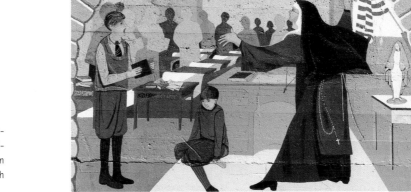

The Singing Lesson. In this scene, set inside St. Joseph's School in the 1930s, a nun conducts a singing lesson with her class. While students—most of them children of immigrants—sing, a boy who has been naughty sits on the Sister's platform, a customary form of punishment practiced in years gone by. This last mural reveals the extent to which Slovenian children became woven into the fabric of American life.

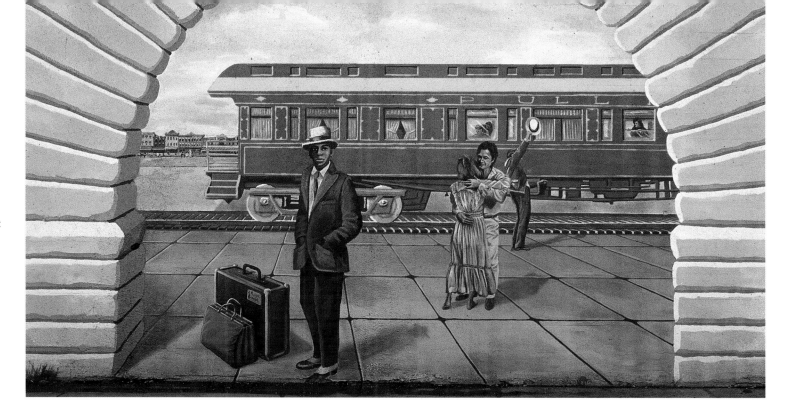

 27

Joliet Steam Train 1994

North side of East Washington Street
between Chicago Street and
Scott Street

Ten murals
10' H x 11' W
acrylic on brick

Lead Artists:
Kathleen Farrell
and Kathleen Scarboro

Assistant Artists:
Sergio Gomez, Javier Chavira
and Dante DiBartolo

This set of ten murals, painted along the viaduct west of Union Station, pictures the varied lives and activities of dozens of characters—waiting passengers, vendors, entertainers, and passers-by—gathered around a Rock Island passenger steam train in the early part of the twentieth century.

Railroads have played a key part in Joliet's economic development, labor history, and demographic composition. The construction, maintenance, and operation of the rails and trains provided jobs, as both raw materials and finished goods were hauled in and out of the city. Trains were also the main form of transportation during the nineteenth and much of twentieth centuries; their cargo included European immigrants, as well as African- and Mexican-American migrants who formed the local industrial labor force.

Joliet Steam Train

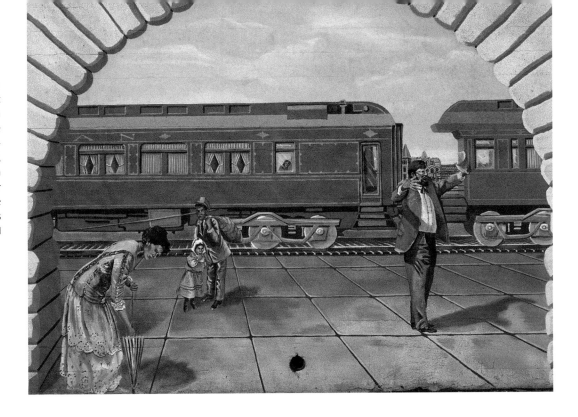

The Chicago and Rock Island Railroad was the first rail line to serve Joliet. Iron rails were shipped to Joliet from Chicago in canal boats as track work progressed from both cities, and the first train steamed into Joliet in October 1852, four years after the Illinois & Michigan Canal was completed. By the next year, two trains were running daily between Joliet and Chicago, providing both passenger and freight service. The Chicago and Alton began service to Joliet in August 1854. Other regional and national lines—including the Michigan Central, the Santa Fe, and the EJ&E —soon also served the city.

The Rock Island line ceased operations in 1980. Two years earlier, however, the Regional Transportation Authority (METRA) took over the main route between Joliet and Chicago, and it still runs a commuter service between the two cities.

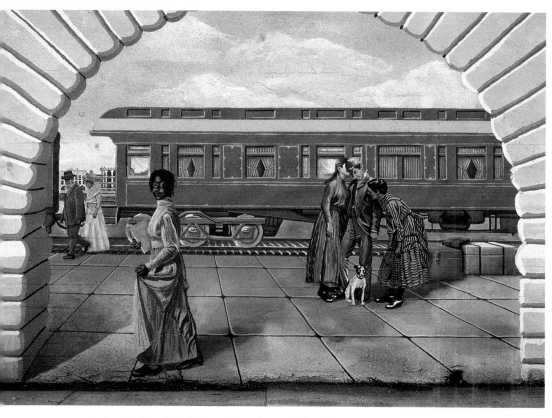

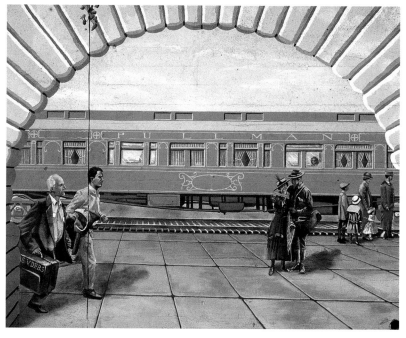

Saying Goodbye. A family shares farewells as an African-American woman trods the platform. The Rock Island was one of many rail lines that brought European immigrants, as well as black and Mexican migrants, to the city. They all became part of the local workforce.

Eugene Debs and the Railway Union. Pictured at the left is Eugene V. Debs (1855–1926). Debs, a former locomotive fireman, city clerk, and state legislator from Terre Haute, Indiana, rose to prominence in 1894 when his American Railway Union (ARU) led a strike against the Pullman Company. Joliet's rail workers, previously organized into five separate craft unions, formed an ARU local and joined a national strike called to boycott trains carrying Pullman sleeping cars (pictured here). Though supported by the Will County Central Trades and Labor Council, workers were opposed by the steel companies, sheriff's deputies, the Grand Army of the Republic (a Civil War veterans' organization), and the local press. The strike collapsed after court injunctions and federal troops were utilized against workers and union leaders. Debs was arrested and sent to jail for contempt. Later, he became a leader and a five-time presidential candidate of the Socialist Party. As such, he visited the Joliet area on numerous occasions.

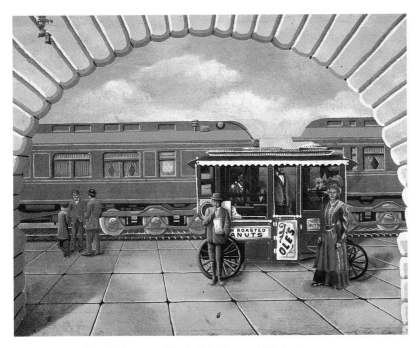

Roasted-Peanut Cart. Such wagons did a brisk business outside depots.

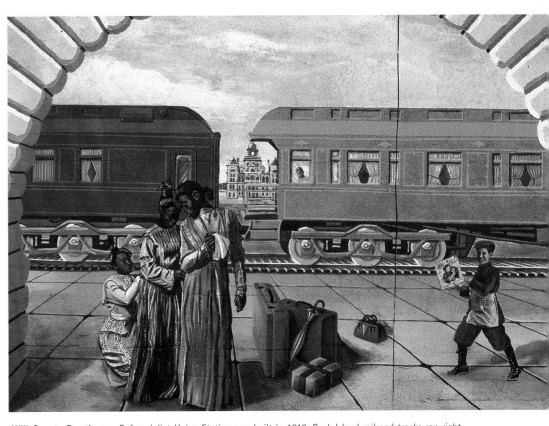

Will County Courthouse. Before Joliet Union Station was built in 1912, Rock Island railroad tracks ran right through the Courthouse Square before entering the business district. This created lots of problems—rumbling trains rattled windows, disrupted court proceedings, and snarled traffic on Chicago and Jefferson Streets. The Will County Courthouse pictured here was the third to occupy the site. Built of local limestone, it was completed in 1887 and stood until the new courthouse was finished in 1969. (A brick outline in the plaza indicates the location of the previous building.) Also, an urchin sells copies of the *Will County Labor Record*, a weekly workers' newspaper.

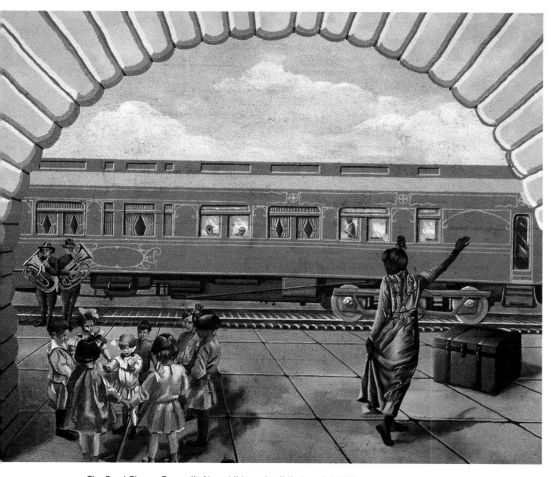

The Band Plays a Farewell. Also, children play "blind man's bluff."

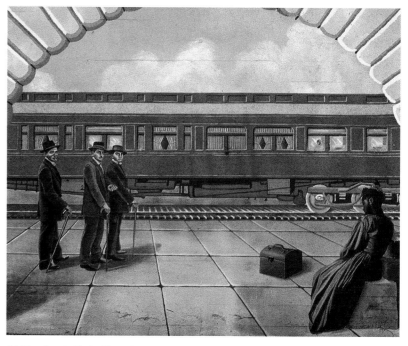

Waiting for the Train. The train linked Joliet citizens to all major cities in the United States.

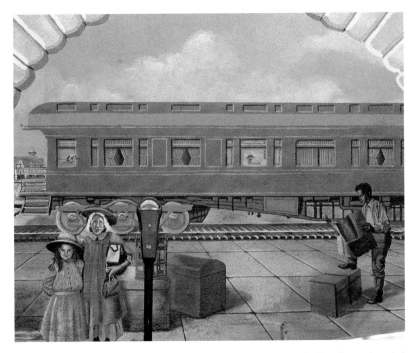

Woodruff Hotel. Pictured in the background on the left is the distinctive, Germanic styled Woodruff Hotel, formerly located on Jefferson Street near Chicago Street. Many train travelers stayed in this elegant hotel, which was built in 1915 and razed in 1971.

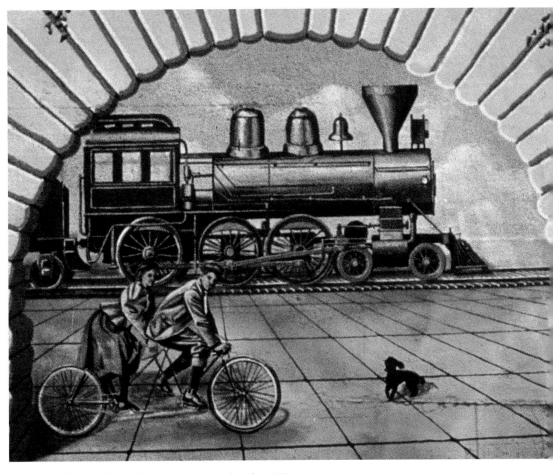

Bicycle Built for Two. Also, an "iron horse" steam engine, circa 1900.

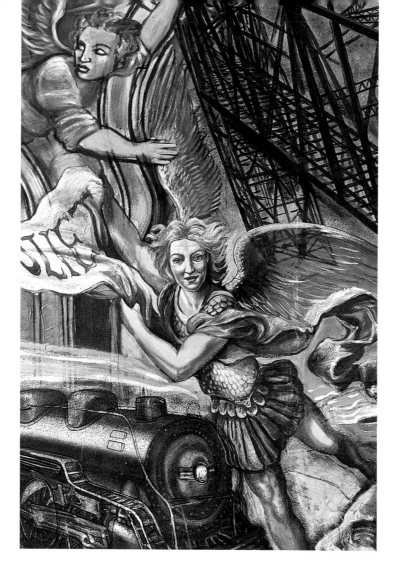

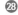 28

Visions of Joliet
1991

Joliet Union Train Station,
inside lower level

7'6" H x 41' W
acrylic on plywood

Lead Artist:
Alejandro Romero

A superlative feat of synthesis and design, this mural by renowned Chicago artist Alejandro Romero takes viewers on a journey through the history of Joliet. Displaying Romero's penchant for bright, lush color, dynamic composition, and layering of images, this civic treasure weaves together—by way of the Des Plaines River—architectural landmarks, people who have shaped the region's cultural heritage, as well as the citizens, workers, unions, and industries that have contributed to Joliet's reputation as the "City of Champions" built from the historic foundations of stone and steel.

References to Joliet's cultural accomplishments include the portrayal of the Rialto Square and Billie Limacher Bicentennial Park Theatres; musicians and instruments reflect the city's rich, diverse musical heritage and nationally renowned school bands and orchestras. The river—with its steel lift bridges, barges, and pleasure boats—plays a vital role in the composition, flowing from one end of the mural to the other.

Images of steel mills, steelworkers, and other trades people, as well as Caterpillar earth-moving equipment, represent Joliet's industrial heritage. Steam and passenger trains highlight the

Visions of Joliet

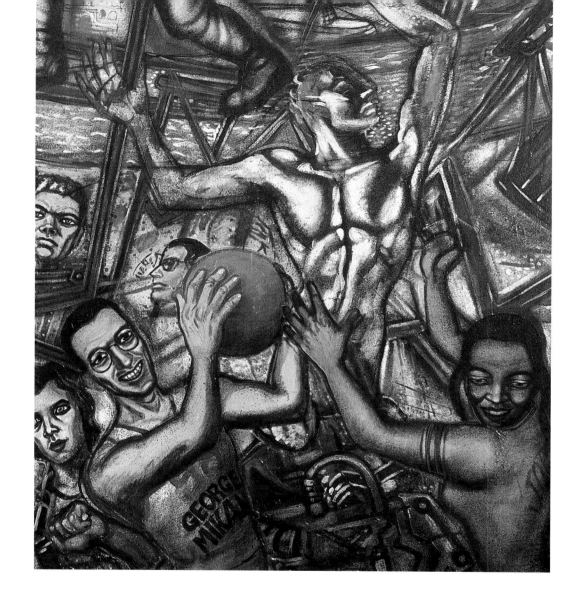

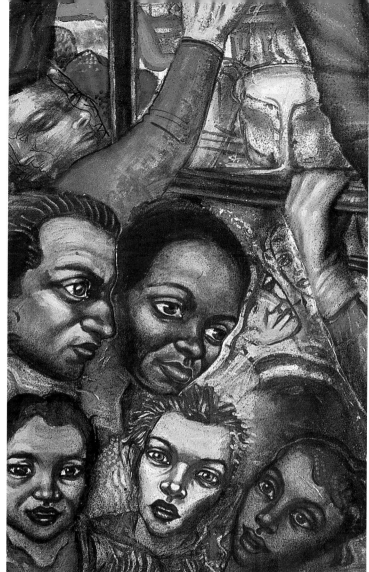

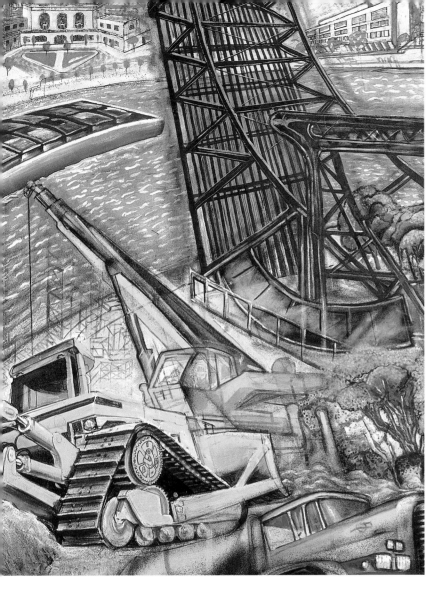

Alejandro Romero

Born: Villahermosa, Tabasco, Mexico 1949

Education/Experience: began art study, National School of Fine Arts' Academy of San Carlos, Mexico, 1967; studied mural painting in the workshops of Juan O'Gorman and David Alfaro Siqueiros, 1969-1970.

Current status: internationally recognized community-oriented painter, muralist, sculptor, and printmaker; living in Chicago since 1976.

The opportunity to freely express myself every day of my life is a great privilege. Not everyone is able to express their talents. I've never regretted it. There is always the pleasure of seeing the continuation and evolution of my work.

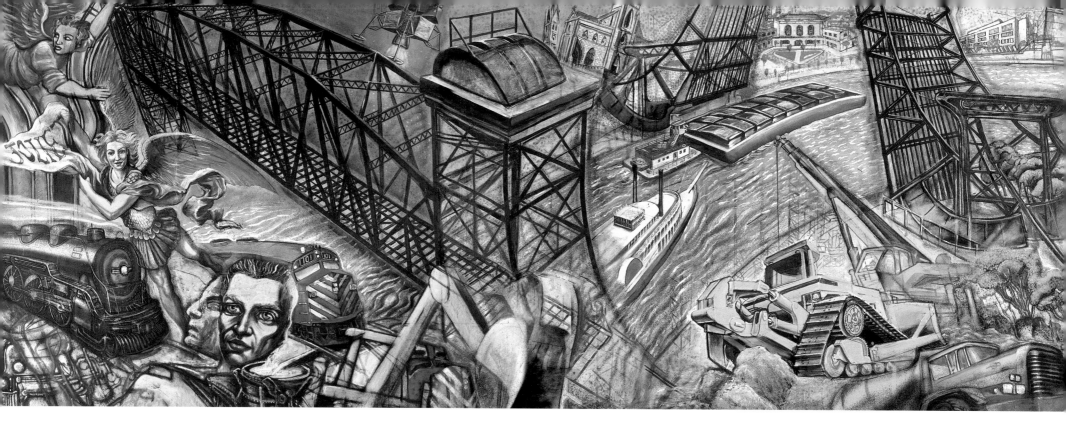

importance of transportation. The first Lunar Module is shown because it was designed in 1961 by scientist John Houbolt, a Joliet native and the namesake for Houbolt Road. Images of prominent historic buildings line the length of the river. Landmarks such as Joliet Central High School, various churches, as well as Union Station itself, honor the city's traditional limestone architecture.

Notable citizens depicted include Theodore Lega, Joliet Central High School band director; Billie Limacher, president of the organization that created Bicentennial Park and the founder of its theater; and sports figures Cathy Boswell (1984 Olympic gold medalist in basketball) and George Mikan (professional basketball player who originally played for DePaul, which retired his number 99). In the center, just below images of men and women union workers building for the future, is the diverse "Faces of Joliet" section. Also included are angelic figures heralding the city's renaissance, Olmec and Aztec figures symbolizing Joliet's Mexican heritage, and a classical figure representing strength and vitality.

Visions of Joliet not only launched the restoration of Union

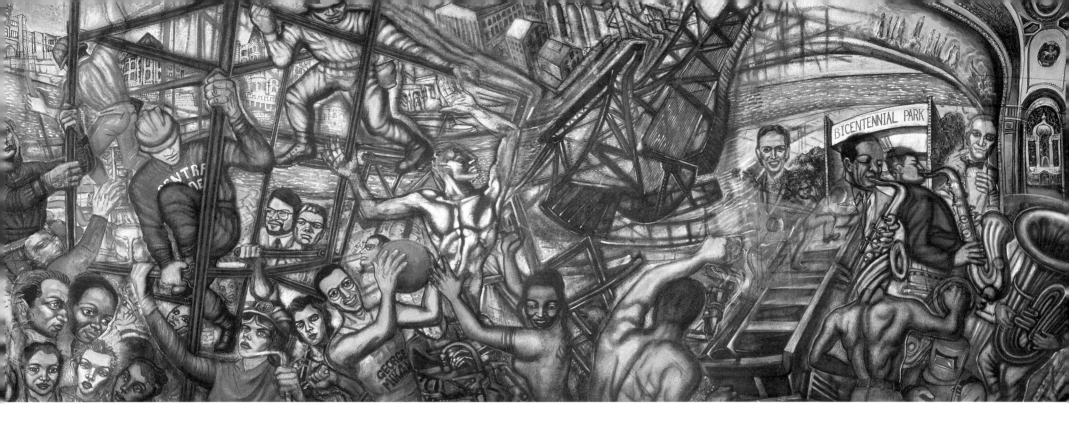

Station, which was brought back to its original luster by 1993; it sparked the city's public art movement. The mural project, organized by Kathleen Farrell, was sponsored by the Illinois State Museum Lockport Gallery and the City of Joliet, with additional support from the Illinois Arts Council, the Cultural Arts Council of the Joliet Area, R.R. Donnelley & Sons Co., Roosevelt Paper Co., the American Federation of Teachers Local 604, Caterpillar, Inc., *Herald News*, Leach Homes, Lyons Lumber, The Spanish Center, Wicklander Printing Corp., and the Will-Grundy Counties Building Trades Council.

The artist painted with airbrushes on plywood panels that were fitted to the curved wall.

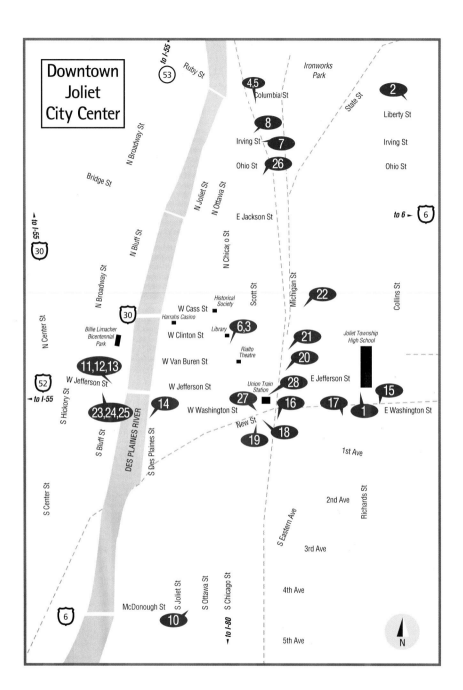

Downtown Joliet City Center

Ironworks Park

(53) Ruby St

State St

4,5 Columbia St

2 Liberty St

8

Irving St — 7 Irving St

Ohio St 26 Ohio St

N Broadway St

Bridge St

N Bluff St

N Chicago St

N Ottawa St

N Joliet St

← to I-55 (30)

N Broadway St

(30)

E Jackson St to 6 ► 6

Historical Society

W Cass St

Harrahs Casino

Library 6,3

W Clinton St

Rialto Theatre

W Van Buren St

Scott St

Michigan St

Collins St

22

21

20

Joliet Township High School

N Center St

Billie Limacher Bicentennial Park

(52)

11,12,13

W Jefferson St W Jefferson St

← to I-55

23,24,25 14

28 E Jefferson St

27 16 17 1 15 E Washington St

W Washington St

New St 18

19

1st Ave

S Hickory St

S Bluff St

S Des Plaines St

DES PLAINES RIVER

Union Train Station

2nd Ave

Richards St

S Eastern Ave

3rd Ave

S Center St

4th Ave

S Joliet St

S Ottawa St

S Chicago St

McDonough St 10

(6) ▼ to I-80

5th Ave

N

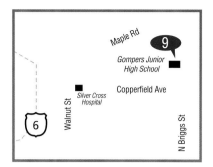

Maple Rd 9

Gompers Junior High School

Copperfield Ave

Silver Cross Hospital

Walnut St

N Briggs St

6

Location of murals

1

The Foundation of Every State Is the Education of Its Youth: Joliet Township High School Centennial
three murals 14' H x 100' W each, (1999)
Location: A,B,C on the north wall of E. Jefferson Street between Eastern Avenue and Richards Street.
a. The Band and Theater *(right section)*
b. Science *(middle section)*
c. ROTC *(left section)*

2

La Herencia Mexicana: Mexican Heritage
10' H x 36' W (1999)
Location: south wall at 617 Collins Street at Liberty Street
Aztec eagle warriors, Mexican-Indian mothers with children, World War II hero Sator Sanchez and many other subjects combine to create a vivid image of the past and present of Joliet's Mexican community.

3

Ancient Traditions, A New Frontier: An Italian Heritage
25' H x 18' W (1999)
Location: north wall of 121 N. Chicago Street at Clinton Street
Joliet's Italian community brought its art, music and cuisine when immigrating into the area in the late 1800s.

4, 5

German Heritage I & II
two murals, 10' H x 35' W (1998-1999)
Location: south side and north side of Columbia Street
Catholic, Lutheran and Jewish German immigrants are portrayed in successive images from a photograph album, connected by a flowing banner of the German national colors, becoming the red, white, and blue of the American flag.
I. Immigration, St. John's Church and nuns working at St. Joseph's Hospital are shown on the south side.
II. Bluff Street Jewish tailor, St. Peter's Lutheran Church, images from farming, a brewery, Sweet Orr Overall Factory and a delicatessen are found on the north side.

6

United We Stand: Irish Heritage
10' H x 20' W (1998)
Location: north wall of 121 N. Chicago Street at Clinton Street
Highlights include early Irish labor history.

7

From the Hands of Ceres: Ode to Will County Farmers
14' H x 40' W (1998)
Location: east side of the 500 block of Scott Street
The mural shows fields of corn and soybeans and the farmers whose labor puts nature's bounty on our tables.

8

E J & E Railroad & Its Mexican Workers
10' H x 26' W (1998)

Location: west side of the 600 block of Scott Street

A symbolic history of the Elgin, Joliet and Eastern Railway and its Mexican railroad yard workers.

9

Gompers' Brotherhood
7' H x 25' W (1998)

Location: east wall of Gompers Junior High School, 1301 Copperfield Avenue

An African sculpture, a Chinese girl, a Native American man and a Mayan corn goddess on a background of paper doll cutouts, symbolizes brotherhood amongst diversity at Gompers.

10

Visions from a Dream: An African American Neighborhood
12' H x 28' W (1998)

Location: north wall of Eliza Kelly Grade School, 100 W. McDonough Street

This amalgamate of images resonates with African-American experience, spirituality, myth and aesthetics. The mural, containing several interconnected themes, particularly honors elder women who pour their knowledge and strength into the community.

The Illinois and Michigan Canal

11

Channahon Lock
17' H x 14' W (1997)

Location: north side of W. Jefferson Street at Bluff Street

The Channahon lock is part of the ninety-six mile long waterway of the Illinois and Michigan Canal that connected Lake Michigan to the Mississippi River in 1848.

12

The Des Plaines River
14' H x 42' W (1997)

Location: west side of Bluff Street near W. Jefferson Street

A view of Joliet's Des Plaines River in the early 1900s and the remains of Joliet's lock number five of the Illinois and Michigan Canal.

13

Cargo Boat
15' H x 38' W (1998)

Location: north of the Des Plaines River mural on the west side of Bluff Street

Mules pulled cargo boats on towpaths adjacent to the Illinois and Michigan Canal.

14

Joliet Limestone: Our Canals & Quarries
10' H x 60' W (1997)

Location: east retaining wall of the Des Plaines River at Washington Street

Workers dig Joliet limestone to build the Illinois and Michigan Canal in 1840 and the Sanitary and Ship Canal in 1900.

15

Selling Sentiment: Gerlach-Barklow
10' H x 36' W (1997)

Location: northeast corner of E. Washington Street at Richards Street

The Gerlach Barklow printing company, which once covered the entire city block across the street from the mural, was the nations' largest producer of calendars, fans and other novelties featuring sentimental paintings and advertising. Later under the name Rust-Craft the company produced greeting cards.

16

Joliet: A City of Steel
10' H x 35' W (1997)

Location: north east corner of Michigan Street at E. Washington Street

Joliet's steel mills, its workers and its products are displayed.

17

Joliet's History, Our History: African-Americans
10' H x 16' W (1997)

Location: northeast corner of E. Washington Street at Eastern Avenue

Former slave and abolitionist Frederick Douglas, a church singer, and a coal miner are a few of the characters presented together in this homage to contributions of the Joliet African-American community.

18

Sauk Trail
12' H x 24' W (1996)

Location: New Street at the pedestrian crossing for Union Station

Various aspects of the Joliet area's Native American heritage are explored, including a map of the Great Sauk Trail, a Potawatomi child and a traditional temporary shelter.

19

Hickory Creek in the 1830s
12' H x 24' W (1996)

Location: New Street at the pedestrian crossing for Union Station

Images of the original Red Mill, the Cagwin Saw Mill and the old Richards Street stone bridge are combined with serene scenes illustrating pioneer children playing along Hickory Creek.

20

Joliet's Love of Music
10' H x 12' W (1996)

Location: northwest corner of Michigan Street at Van Buren Street

The excellence of local musicians earned Joliet the title of "City of Champions".

21

La Katerina: Katherine Dunham
10' H x 12' W (1996)

Location: southwest corner of Michigan Street at Clinton Street

Internationally acclaimed Joliet dancer and choreographer Katherine Dunham introduced African/Caribbean dance traditions into modern dance in the late 1930s. She also promoted the role of music and dance in struggles for social justice.

22

Papering the World: Joliet's Wallpaper Industry
12' H x 32' W (1996)

Location: northwest corner of Michigan Street at Cass Street

By 1922 Joliet was the largest producer of wallpaper in America.

23

Bluff Street Architecture in 1840
20' H x 70' W (1995)

Location: south side of W. Jefferson Street at Bluff Street

Merchant's Row, the first commercial building in Joliet, is depicted on the left side of the mural. On the right side is a view of St. Patrick's church tower on W. Jefferson Street in the 1870s.

24

A Patchwork of Hearth & Home: Women & Children of Bluff Street
20' H x 70' W (1996)

Location: under the Broadway Street overpass on the south side of W. Jefferson Street

A Potawatomi baby, Fort Nonsense and the first Joliet school, are woven into a design based on nineteenth century patchwork quilts. The mural pays homage to the role played by women and children in pioneer-era Bluff Street.

25

Bustling Bluff Street in the 1800s
13' H x 273' W (1995)

Location: south side of W. Jefferson Street between Broadway Street and Hickory Street

Mural scenes from the left to the right are:
a. John Paige Bottling Co., one of the first carbonated beverages companies in the U. S.
b. Mr. & Mrs. Martin Demmond: Joliet's first builders
c. George Woodruff, Joliet's first historian
d. Othello at Merchant's Row, performed at Joliet's first theater in 1842.
e. Barrett's Hardware, first located on the corner of Bluff and W. Jefferson Streets.
f. Juliet Courier, Joliet's first newspaper, and precursor to the Herald News.

26

From Slovenia to America
10 murals, 10' H x 11' W each (1994-1997)

Location: east side of Scott Street at Ohio Street

Scenes sequentially portray the transition from traditional life in Slovenia to life and work in Joliet.
a. The Procession
b. A Slovene (Ohcet) Wedding
c. The Harvest
d. The Picnic
e. Departure to America
f. Arrival in the City
g. Working in the Steel Mills
h. Slovene Home Making
I. The Playground
j. The Singing Lesson

27

Joliet Steam Train
10 murals, 10' H x 11' W each (1994)

Location: east side of E. Washington Street between Chicago Street and Scott Street

Passengers, vendors, entertainers and passers-by gather around a Rock Island passenger steam train in the early part of the twentieth century.
a. A. Philip Randolph and The Pullman Porter Union
b. Free Speech
c. Saying Goodbye
d. Eugene Debs & the Railway Union
e. Roasted Peanut Cart
f. Will County Court House
g. The Band Plays A Farewell
h. Waiting for the Train
I. Woodruff Hotel
j. Bicycle Built for Two

28

Visions of Joliet
indoor mural, 7'6" H x 41' W (1991)

Location: interior of Union Train Station, Scott Street at E. Jefferson Street

Images of architectural landmarks, people who have shaped the cultural heritage of the region, workers, and industries are woven together around a view of the Des Plaines River.

Selected Resource Guide

Joliet History Organizations

Joliet Area Historical
Society Museum
17 E. Van Buren Street
Joliet, IL 60432
(815) 722-7003

Will County Historical Society
803 S. State Street
Lockport, IL 60441
(815) 838-5080

Joliet Public Library
150 N. Ottawa Street
Joliet, IL 60432
(815) 740-2660

Isle a la Cache Museum
501 E. Romeo Road
Romeoville, IL 60446
(815) 886-1467

Illinois Department
of National Resources
I & M Canal Visitor Center
Gaylord Building
200 W. 8th Street
Lockport, IL 60441
(815) 838-4830

National Trust for Historic
Preservation
Gaylord Building
200 W. 8th Street
Lockport, IL 60441
(815) 588-1100

Joliet History Books

Conzen, Micheal P., *1848:
Turning Point for Chicago, Turning
Point for the Region*. Newberry
Library, Chicago, 1998.

Lamb, John, *A Corridor in Time*.
Lewis University,
Romeoville, IL, 1987.

Rajala, Hope, *Black & White
Together*. Will County Historical
Society, Joliet, IL, 1971.

Rajala, Hope, *Will County
and the Barbed Wire Industry*.
Hope Rajala, Joliet, IL, 1975.

Shaw, Fayette B., *The Economic
Development of Joliet, Illinois,
1830–1870*. Fayette B. Shaw,
Joliet, IL, 1934.

Sterling, Dr. Robert, *A Pictorial
History of Will County*, vols. 1
and 2. Will County Historical
Publications Co., Joliet, IL, 1975.

Sterling, Dr. Robert, *A Pictorial
History of Joliet*. G. Bradley
Publishing, Inc.,
St. Louis, MO, 1986.

Sterling, Dr. Robert, *Joliet
Transportation and Industry:
A Pictorial History*. G. Bradley
Publishing, Inc.,
St. Louis, MO, 1997.

Vasile, Ronald S., *I & M Canal
Pioneers' Stories: Bringing History
to Life in the Illinois and Michigan
Canal National Heritage Corridor*.
Canal Corridor Association,
Chicago, 1999.

Woodruff, George, *A History of
Will County*. Wm. LeBaron,
Jr. & Co., Chicago, 1878.

Joliet History Articles

Farrell, Kathleen, and Steven
Freedman, *Will County Labor
History 1870–1920*. Joliet
Township High School District
204 (pamphlet), Joliet, IL, 1980.
Freedman, Steven, Organizing the
Workers in a Steel Company
Town: The Union Movement in
Joliet, 1870–1920. *Illinois
Historical Journal*, vol. 79,
Spring 1986, pp. 2–18.

Gottlieb, Am Zahl, British Coal
Miners: A Demographic Study of
Braidwood and Streater, Illinois.
*Journal of the Illinois State
Historical Society*, Issue 72, 1979,
pp.179–92.

Joyce, Richard, Miners of the
Prairie: Life and Labor in the
Wilmington, Illinois, Coal Field:
1866-97. Masters Thesis, Illinois
State University, 1980. Available
at the Joliet, Morris, Braidwood,
Coal City, and Wilmington
Public Libraries.

**Community Public Art
Organizations**

Friends of Community Public Art
(FCPA)
1819 N. Center Street
Joliet, IL 60435-2531
(815) 722-4140

Chicago Public Art Group (CPAG)
1259 S. Wabash Street
Chicago, IL 60605
(312) 427-2724

Social and Public Art Resource
Center (SPARK)
685 Venice Boulevard
Venice, CA 90291
(310) 822-9560

Community Public Art Books

Barnett, Alan W., *Community
Murals: The People's Art*.
The Art Alliance Press, Inc.,
Philadelphia, 1984.

Cockcroft, Eva, John Pitman Weber, and James Cockcroft, *Toward a People's Art: The Contemporary Mural Movement*. E. P. Dutton & Co., Inc., New York, 1977.

Doss, Erika, *Spirit Poles and Flying Pigs: Public Art and Cultural Democracy in American Communities*. Smithsonian Institution Press, Washington, DC, 1995.

Drescher, Tim, *San Francisco Bay Area Murals: Communities Create their Muses*. Pogo Press, St. Paul, MN, 1998.

Dunitz, Robin, and James Prigoff, *Painting the Towns: Murals of California*. RJD Enterprises, Los Angeles, 1997.

Foner, Philip S., and Reinhard Schultz, *The Other America: Art and the Labor Movement in the United States*. Journeyman Press, West Nyack, NY, 1985.

Gude, Olivia, and Jeff Huebner, *Urban Art Chicago*. Ivan R. Dee, Chicago, 2000.

Hurlburt, Laurance P., *The Mexican Muralists in the United States*. University of New Mexico Press, Albuquerque, 1989.

Marling, Karal Ann, *Wall to Wall America: Cultural History of Post Office Murals in the Great Depression*. University of Minnesota Press, Minneapolis, 1982.

Mueller, Mary Korstad, *Murals: Creating an Environment*. Davis Publications, Inc., Worcester, MA, 1979.

O'Connor, Francis V., *Art for the Millions*. New York Graphic Society Ltd., New York, 1973.

Park, Marlene, and Gerald E. Markowitz, *Democratic Vistas: Post Offices and Public Art in the New Deal*. Temple University Press, Philadelphia, 1984.

Prigoff, James, and Robin Dunitz, Walls of Heritage: *Walls of Pride: History of African American Murals*. Pomegranate Press, Rohnert Park, CA, 2000.

Rivera, Diego (with Gladys March), *My Art and My Life: An Autobiography*. Dover Publications, New York, 1991.

Rochfort, Desmond, *Mexican Muralists: Orozco, Rivera, and Siqueiros*. Universe, New York, 1993.

Seligman, Patricia, *Painting Murals: Images, Ideas and Techniques*. North Light Books, Cincinnati, OH, 1988.

Community Public Art Articles

Huebner, Jeff, Nowhere to Go But Up, *Public Art Review*. Fall/Winter, Minneapolis, MN, 1996.

Huebner, Jeff, Labor Mural Art of Kathleen Farrell, *Labor's Heritage*. Vol. 8/ No. 4, Spring 1997.

Museum Catalog

Musee de l'Homme, *La Reunion: Deux Regards, Kathleen Scarboro Peinture-Miroir et Jean Philippe, Vivre a Mafate by Nicole Boulfroy*. Museum of Mankind (Musee de l'Homme), Paris, France, 1995.

Index

Artists, Assistant Artists, and Subject of Murals